Giovanna Magi

THE GRAND LOUVRE AND THE MUSEE D'ORSAY

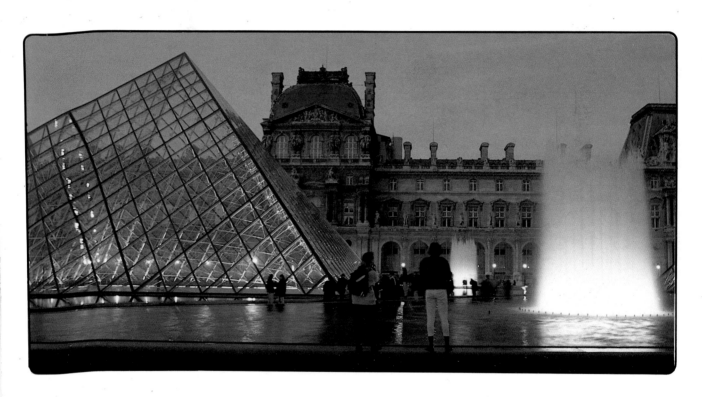

Photographs by
Réunion des musées nationaux

BONECHI

ISBN 88-7009-780-3

PHOTO CREDITS

Photographs of the works of art: © Photo R.N.M.
Photographs on pages 3, 9, 84: by Paolo Giambone.

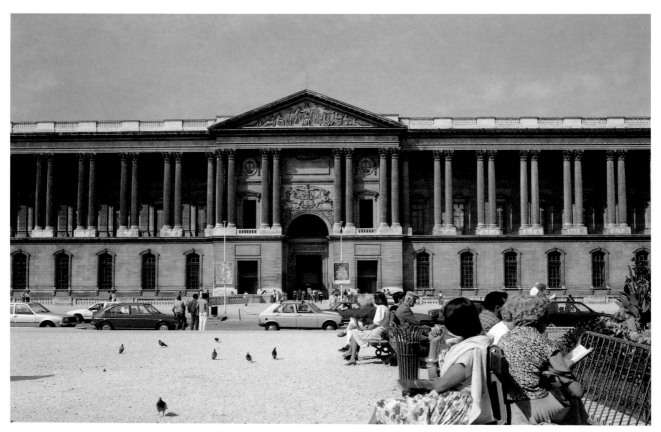

The Louvre Museum, main entrance.

THE LOUVRE MUSEUM

THE PALACE

The Louvre dates back to 1200, when Philip Augustus had a fortress built near the river for defense purposes: it occupied more or less a fourth of today's Cour Carrée. The fortress was not, then, the royal residence (the king, in fact, preferred living in the Cité) but it housed, among other things, the royal treasure and the archives. In the 14th Century Charles V, the Wise, rendered the fortress more habitable and took it as his residence. One of his additions was the famous Librairie. After his reign the Louvre was not used as the royal residence again until 1546, when Francis I commissioned the architect Pierre Lescot to improve the residence and render it more in keeping with the new Renaissance tastes. He had the old fortress demolished and began the construction of the Southwest wing of what is now the Cour Carrée. Work continued under Henri II. After his death, Caterina de' Medici entrusted Philibert Delorme with the construction of the Tuileries Palace and a great gallery flanking the Seine was to join it to the Louvre. Work, interrupted at Delorme's death, continued under Henry IV, who had the Great Gallery and the Pavillon de Flore terminated. The enlargement of the edifice continued under Louis XIII and Louis XIV; the architects Lemercier and Le Vau gave the Cour Carrée its present form; Claude Perrault was commissioned to build the east façade with its colonnade. When the court moved to Versailles in 1682, work on the Louvre was almost totally abandoned: even the palace itself became so rundown that in 1750 it was thought to demolish it outright. One may say that the women of the Parisian markets saved the Louvre when they marched on Versailles on October 6, 1789 to bring the royal family back to Paris. After the tumultuous years of the Revolution, Napoleon I, finally took up work on the Louvre again. His architects, Percier and Fontaine, began construction of the north wing along the Rue de Rivoli. It was finished in 1852 under Napoleon III, who decided, finally, to complete the Louvre. With the fire and consequent destruction of the Tuileries during the siege of the city in May of 1871, the Louvre took on its present aspect.

3

THE COLLECTIONS

The collection of works there exhibited is so vast that the Louvre has often been defined "the world's most important museum." From an initial nucleus of works, the Louvre collection grew with the collections of the Kings of France; its continual expansion has since been assured by a wise buying policy and generous donations. Francis I is unanimously recognized as the founder of this important collection. The sovreigns preceding him had commissioned and brought works of art – especially paintings – but until this time these were isolated episodes. Francis I (1515-1547) began a real and proper collection of all genres of works in order to enrich the royal residence at Fontainebleau. He will succeed in commissioning the most important artist of the times, Leonardo da Vinci, and thus in attaining ownership of some of Leonardo's most important works: for example, the "Monna Lisa" and the "Virgin of the Rocks". During the same period, works by such Italian artists as Andrea del Sarto, Titian, Sebastiano del Piombo, Raphael will become part of the collection. Francis I's successors will not show much interest in the collection of works of art. They will limit themselves to commissioning a few portraits by contemporary French artists: Clouet and Corneille, for example. A further impetus was given to the collections during the reign of Louis XIII: even though he was rather indifferent to artistic matters, his celebrated Minister, Cardinal Richelieu, was a true collector. At his death Richelieu left his collections to the Crown, whose holdings were thus enriched by such masterpieces as "The Pilgrims of Emaus" by Veronese and Leonardo's "Saint Anne". Maria de' Medici, the King's mother, also contributed to the growth of the collection: she ordered a certain number of canvases from Rubens for her new residence in Luxembourg. Nevertheless the collection was still relatively modest. An appraisal of the time counts 200 paintings.

With the successor, Louis XIV, the collection will make some really important progress: it is enough to recall that, at the time of his death, the "Royal Collection" counted over 2000 paintings. First the king was wise enough to buy, at his Minister Colbert's suggestion, a part of Cardinal Mazarino's collection. He then had the great good luck to be able to buy the collection of Charles I of England, which Cromwell had put up for sale. This collection was very important in that it had previously absorbed the collections of the Mantuan Gonzaga princes. The Sun King, moreover, will collect numerous works by such French authors as Poussin, Lorrain, Le Brun, Mignard. His successor, Louis XV, was not as capable. Only a very few works by deceased artists will enrich the collection; nevertheless, he will purchase numerous works by such contemporary authors as Chardin, Desportes, Vernet, Van Loo, Lancret. Under Louis XVI numerous works by 17th century Italian artists were acquired: these came from Amedeo di Savoia's collection, dispersed with the Succession. During Louis XVI's reign demands that the royal collections be opened to the public became more insistent. Already in 1749 an exhibition of a limited selection of the works was opened in the Palais du Luxembourg. Diderot had explicitly asked, in 1765 in the Encyclopaedia, that the Louvre be used for the exhibition of the works contained in the Royal Collection. This turmoil was beard by the "Constructions Director" Count d'Angiviller, who planned the "Grande Galerie" especially for this purpose. Moreover, he filled in some of the gaps in the collection: he completed the representation of French artists and purchased numerous works of the Flemish school. Nevertheless the project was still incomplete at his death: only the Revolution will finally put it into effect.

In 1792 the revolutionary government decided to transfer the Royal Collections, now property of the Nation, to the Louvre. The "Central Museum of Art" opened on August 10, 1793, with the presentation of a selection of 587 works. New work was undertaken to make room for the works confiscated from churches, noble families and local administrations that had been abolished, will come to the Louvre in this period. Under Napoleon, the Museum will be enlarged and transformed. The Department of Greek and Roman Antiquity will be formed; the archaeological collections will grow. Nevertheless, the Egyptian Antiquities Department will not be founded until 1826. The Emperor established a system of acquisitions which, although it seems highly criticizable today, was at the time considered not only admissible but even "glorious". He "requisitioned" works of art from the conquered countries and sent them to the Louvre (then called "Napoleon Museum"): an enormous number of works was directed toward France from Belgium, Holland, Germany, Austria and Italy. This will prove, however, to be a short-lived enlargement: by the end of 1815 about 5000 of these works will have been returned to their legitimate owners. Nevertheless, thanks to various agreements and particular exchanges, and also to certain subterfuges, a hundred or so works will remain in Paris. In the 50 years following expansion will center on the Oriental collections: the Assyrian Collection will profit from Botta's expedition, the Egyptian Collection from the illuminated guidance of Champollion, the decipherer of hieroglyphics. Other important additions to the collection will be made under Napoleon III: the purchase of the Campana collection and the acquisition of the La Caze bequest containing enormously important works by Watteau, Fragonard, Chardin, Hals. From this time on the acquisitions policy continued and led to the enlargement of the collections. Nor must we forget the great merit of the numerous patrons of the arts who were to donate their collections to the Museum.

The Castle of the Louvre as it appears in the Paris -
Parlement altarpiece by an anonymous Flemish painter
active in Paris in the middle of the 15th century.

THE GRAND LOUVRE

*From the very beginning, when it was first installed
in the palace of the Louvre in 1793, the museum has
had to suffer all the limitations of a building which
was never meant to be used for this scope. The space
required for a coherent presentation of the collec-
tions, which are among the richest in the world, and
their exhibition to a vast public, was insufficient. The
Louvre was, in other words, a museum filled to over-
flowing, and ill equipped to receive the growing num-
ber of visitors.*
*When, in 1981, it was decided to turn the entire
palace over to the collections, transferring the Minis-
try of Finance to Bercy, François Mitterand initiated
a vast and ambitious program for the restructuration
of the Museum. Studies in museology and town plan-
ning were the first steps towards the achievement of
the Grande Louvre, and the Chinese-born American*

*architect, Ieoh Ming Pei, was entrusted with the or-
ganization of the Cour Napoléon as reception center
for the museum, and with the finalization of a pro-
gram for the redistribution of the collections within
the new spaces.*

COUR NAPOLEON

*The two long buildings which faced each other made
a centralization of the basic functions of the museum
essential. By using the area under the Cour Napoléon
for this scope, in 1983 I. M. Pei designed a vast
under-ground hall set at the center of the court under
a pyramid in transparent glass that was supported by
a fine network of metal cables. Twenty-one meters
high, the pyramid is surrounded by seven basins and
by fountains, and is flanked by three low pyramids*

5

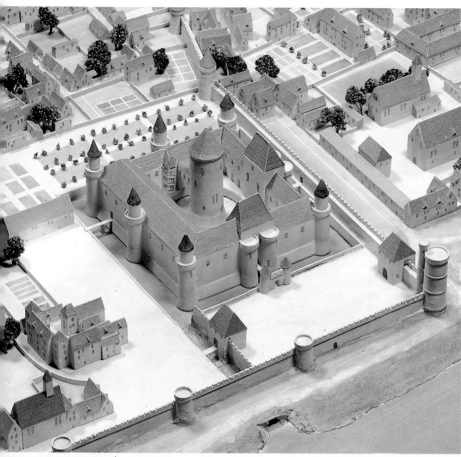

Two pictures of the moat and ▶ the basement of the keep dating to the period of Philippe Auguste and Charles V.

Model of the Palace of the Louvre (scale 1:1000; executed by R. Munier and S. Polonovski): the Louvre as it was in 1380 at the time of Charles V, in 1715 and in 1870.

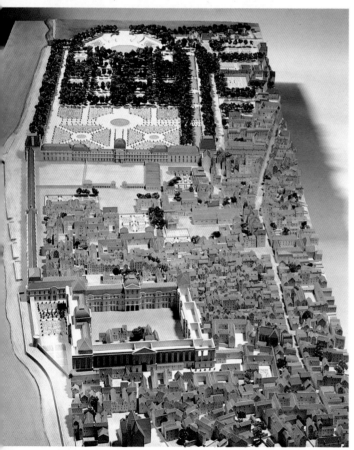

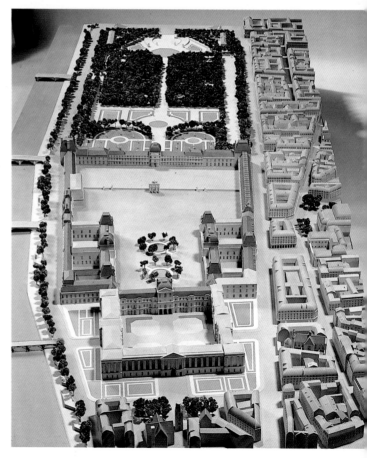

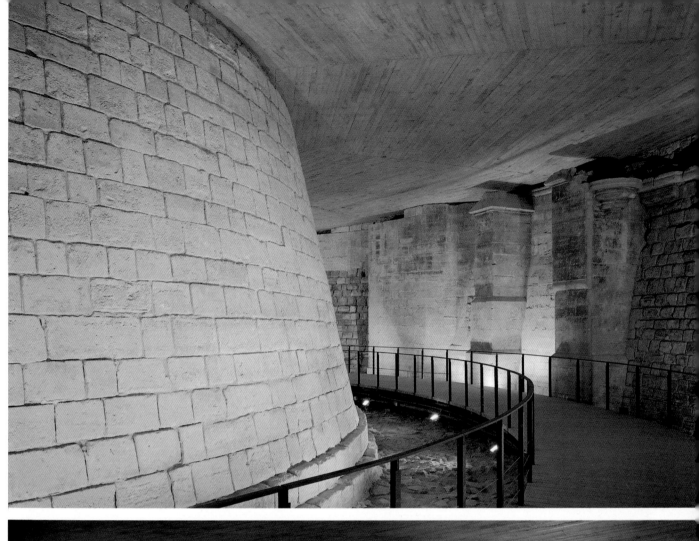
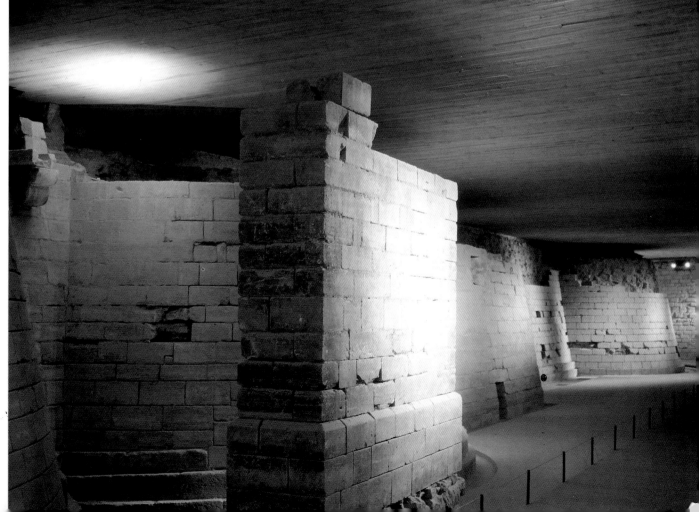

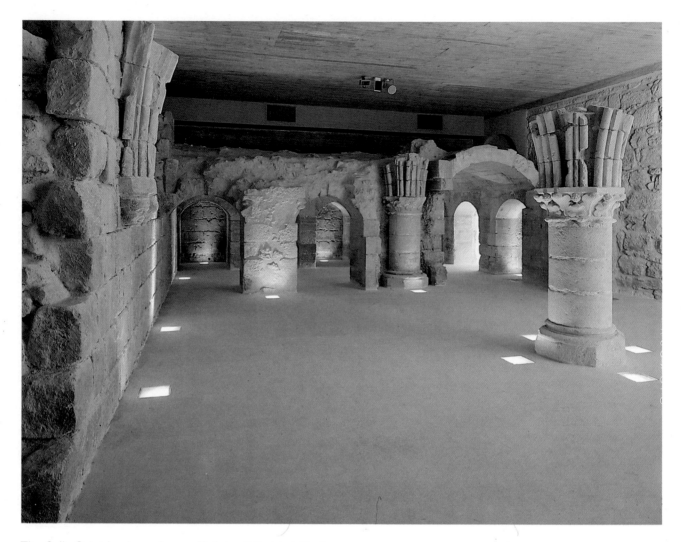

The Salle Saint-Louis, or Lower Hall, is all that is left of
the medieval parts of the old Louvre.

which provide light for the entrance galleries to the
three wings of the Museum (Richelieu, Sully, Denon)
where the collections will be redistributed.
For quite some time the pyramid was hotly debated.
Actually the operation was anything but simple: a
modern complex for the reception of the public, fur-
nished with all the technical requisites indispensable
for the life of a modern museum, had to be built in
the heart of this historical site, which many con-
sidered already full to the brim with architecture and
history. Without in the least changing the exterior
aspect of the building, the solution adopted permits
the focalization of the main entrance without con-
cealing the palace and provides sufficient illumi-
nation for the enormous subterranean space. The
transparency of the pyramid, with its pure geometric
forms, reminiscent of ancient architecture, permits
the visitor to remain in constant visual contact with
the Palace of the Louvre.
The reception hall under the pyramid is also flanked
by an auditorium, a space for temporary exhibitions,
and a new section dedicated to the history of the
Palace. A chronological exhibit of documents, pro-
jects, prints, drawings, models and original works
which bear witness to the various stages in the history
of the Louvre, is to be found in the two rooms which
flank the hemicycle where the vestiges of the decor-
ation created by Jean Gujon (1510-1566) for the
upper part of Pierre Lescot's building are on ex-
hibit.

CASTLE OF PHILIPPE AUGUSTE

The achievement of the Grande Louvre was accompanied by an extensive scientific project aimed at highlighting the history of the Palace with archaeological excavations in the Cour Carrée, in the Cour Napoleon and in the Cour du Carrousel.

The excavations begun in 1983 under the Cour Carrée have brought to light the foundations of the original fortress of Philippe Auguste.

Access to the moats of the outer circle of walls is under the Pavillon Sully. Still extant is the foundation of the imposing defensive system, about six meters high, composed of a square with circular towers, built by Philippe Auguste at the end of the twelfth century. The pylon of the drawbridge in the north moat was added to this system by Charles V, thus permitting him to reach the garden.

A tunnel that passes through the eastern curtain wall leads to the Keep and the Room of St. Louis, which the king had vaulted in 1230-1240. It lies under the present Room of the Caryatids.

The new architectonic order of the "Grand Louvre".

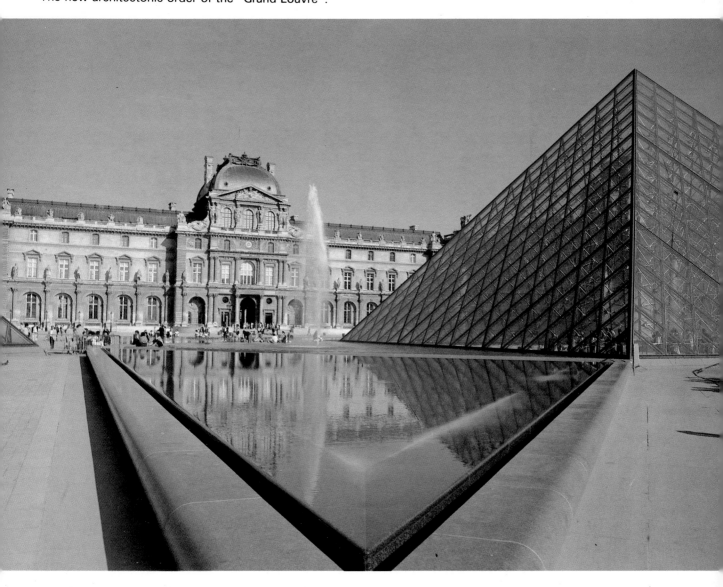

9

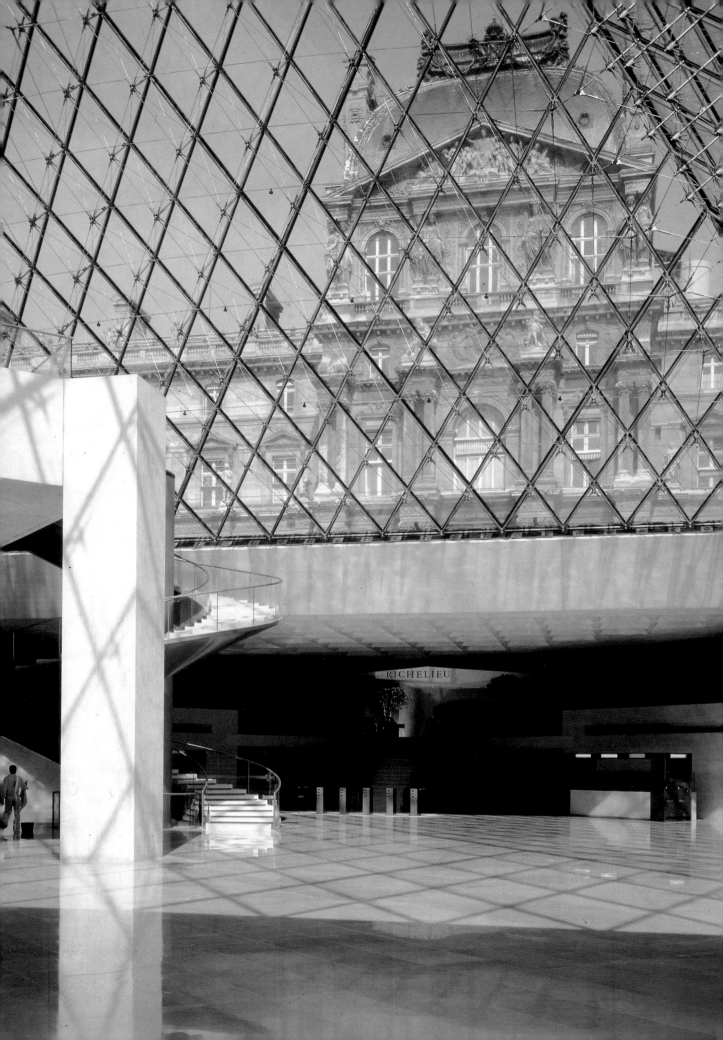

RICHELIEU

REORGANIZATION OF THE COLLECTIONS

As of now, twelve rooms dedicated to French fourteenth-seventeenth century painting have been opened on the second floor of the Cour Carrée. New itineraries will eventually also include the other two wings of the court.

But not until the opening of the Richelieu Wing in 1993, bicentennial of the Museum of the Louvre, will the collections finally be installed in a logical coherent order.

In general the exhibitions will be arranged as follows:

Denon Wing*: The Grande Galerie and the adjacent rooms will be devoted entirely to Italian painting. Only the very large works of early nineteenth-century French painting will remain in the cyma (Galerie Mollien and Galerie Daru).*

The Egyptian, Greek and Roman antiquities are already housed in their definitive exhibition space in the eastern part of the wing and the rooms of the Cour Carrée which face the Seine.

Richelieu Wing*: With the exception of the «Morny rooms» with their fine Napoleon III decor, and which are to be preserved in their present state without the addition of objects from the collections, this wing will house French sculpture and Oriental antiquities on the ground floor in the rooms around the three covered courts, where monumental sculpture will be shown (including the* **Winged Bulls** *from Khorsabad and the* **Marly Horses** *by Coysevox and Coustou).*

Art objects will be located on the first floor while the second will contain the entire collection of Northern painting as well as Rubens' paintings from the Medici Gallery.

◄ A striking picture of the Richelieu Pavilion seen from inside the base of the Pyramid.

The Gallerie d'Apollon.

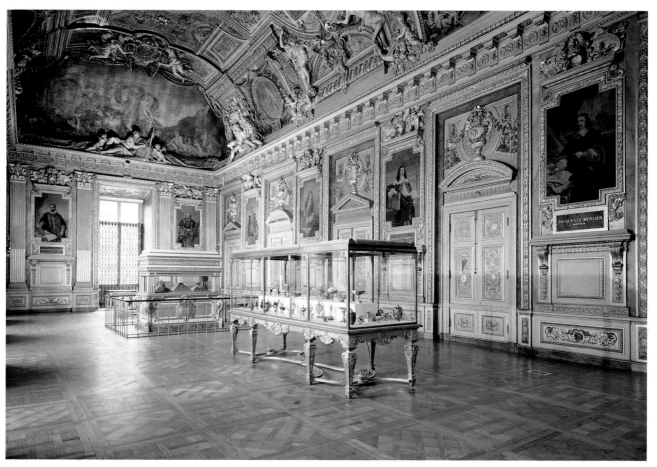

11

ORIENTAL ANTIQUITIES

Ever since its institution, the section of Oriental Antiquities has been linked to the archaeological discoveries in the Near East made in the course of the nineteenth century.

An initial «Assyrian Museum» was inaugurated in 1847 by Louis Philippe after the discovery of the site of Khorsabad in northern Mesopotamia by Paul-Emile Botta. The **Winged Bulls** *which guarded the entrance to the Assyrian palace of Sargon II (724-705 B.C.) bear witness to this vigorous art which began in the ninth century B.C. Masters of the East from the ninth to the seventh century, the Assyrians built enormous palaces which were decorated with bas-reliefs which served to glorify the feats of the sovereigns.*

Thirty years later Ernest de Sarzec began to explore the southern part of what is now Irak and on the site of modern Telloh unearthed the impressive series of statues of **Gudea**, *the first evidence of a much older civilizations (circa 2150 B.C.). As a result, the section of «Oriental Antiquities» was established in 1881. After the fall of the early Sumerian dynasties, Gudea, prince of Lagash, initiated a renaissance of the arts devoted to the exaltation of an ideal of serene piety.*

Even earlier is the statue of the **Intendant Ebih-II** *(2400 B.C.), discovered in Mari by André Perrot in 1934. A holy image placed inside a sanctuary, this work testifies to the high degree of refinement achieved by Sumerian sculpture in the course of the third millennium.*

In the sixth century the region gradually passed first under the dominion of the Chaldean kings, and then under that of the powerful Persian empire, which had sprung up in western Iran (see the bas-relief of the **Archers of Darius** *from Susa).*

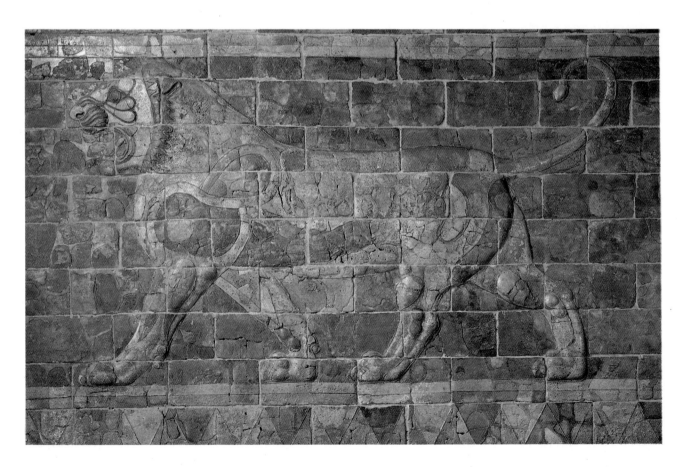

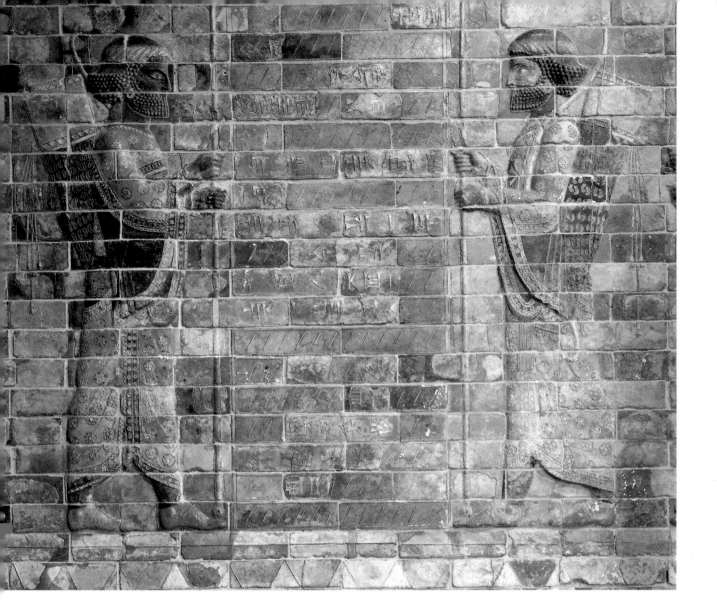

Lions

The art of Asia Minor frequently represented animals in its sculptural works, both in ceramics and in stone. These lions, whose feline pace has been successfully rendered with litheness and ease of movement by the unknown artist, come from the Imperial Palaces of Susa. Susa was, with Persepoli, one of the capitals of the kingdom of the Achaemenid Dynasty.

The Archers of Darius

These famous archers, made from glazed brickwork (since Mesopotamia had very little stone, its buildings were constructed from bricks baked in the sun and then enamelled), are the so-called Immortals, the private guard of the King. The archers, each one 60 inches high, make up an endless procession covering the walls of the luxurious palace of Darius at Susa. The archers differ from one another in minute details, and this almost monotonous repetition of the same figure gives the impression of endless, uninterrupted movement. Their stately and dignified poses and the brilliant colours of their clothing make them a sort of hymn celebrating the greatness and might of the Persian Empire. They belong to the 5th century B.C., the time of Achaemenid dynasty, whose dominions extended for almost two centuries throughout the entire Middle East.

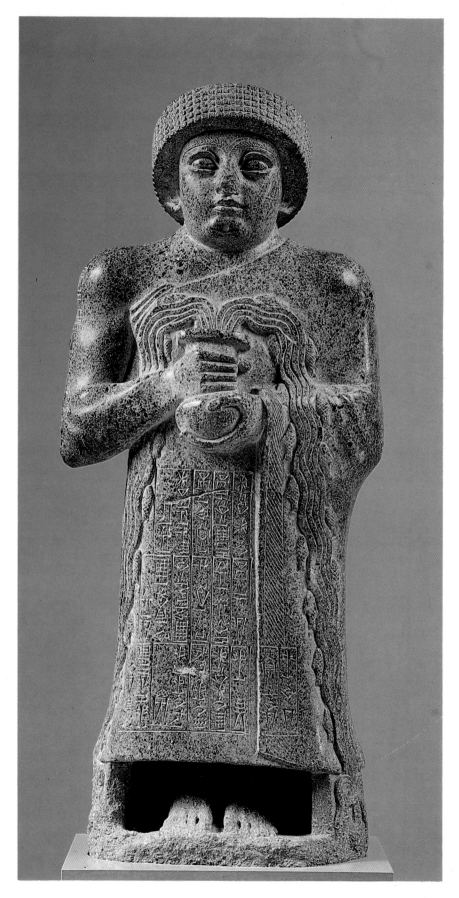

Standing figure of Gudea

Among the extant neo-Sumerian statues, which stylistically are a continuation of the preceding period under the dynasty of Akkad, are about 30 works depicting Gudea, the «patesi» of the city of Lagash. The Sumerians used the name «patesi» to indicate a dignitary who occupied both a political and religious position: Gudea refused the title of king and would accept only this designation. Most of the statuettes were found during excavations by the French at Tello. Gudea is depicted in both sitting and standing positions, but in each work his hands are joined in the act of prayer. This is one of the most famous and finest of the statuettes because of its simplicity and intense religious spirit; made from diorite, it is 41 inches high. The figure wears a typical Persian lamb's wool hat on the head and a simple cloak on the shoulders. Acquired by the Louvre in 1953, it belongs to the «early-dynastic» era, that is between 2555 and 2290 B.C.

Egyptian Art

Seated Scribe

Found in 1852 near Saqqârah in an excavation project directed by Mariette, the Scribe is a masterpiece among Egyptian statues. It belongs to the Old Empire, that is to the time of the 5th Dynasty, and was presumably made in about 2500 B.C. It is 21 inches high and is made of painted limestone, with eyes of semi-precious stones: the cornea is of white quartz, the iris of rock crystal and the pupil of ebony. The Scribe's fixed stare, the rigidly geometric composition and the severely frontal stance of the massive figure are its most obvious features. At the same time, it is animated by an intense sense of internal life: the Scribe seems to interrogate the spectator with his eyes, ready to begin work on the roll of papyrus which rests on his knees.

EGYPTIAN ANTIQUITIES

As in the case of Oriental antiquities, the creation of the section dedicated to Egyptian antiquities was directly dependent on scientific research: in 1826 Champollion, who four years earlier had deciphered the hieroglyphs, was entrusted with the organization of a section on ancient Egypt as part of the new Charles X museum. Thereafter the collections were enlarged by a continuous succession of acquisitions, donations and archaeological excavations, above all those carried out by Mariette in 1852 in Saqqara and in which various masterpieces such as the **Seated scribe**, *or the* **Pectoral in the form of vulture with the head of a ram** *were brought to light.*

The scribe, as well as the **Head of King Didufri**, *date to the Old Kingdom (2700-2200 BC. circa), the glorious period of the great pyramids of Giza and Saqqara, near Cairo. Sculpture of this period is essentially funerary in character: the statue, which rep-resents the deceased, must be a good likeness, and the works of this period are to all effects portraits.*

After the obscure centuries of the First Intermediate Period, which has left few works of art, Egypt once more discovered its unity and force in the course of the Middle Kingdom (2060-1768 B.C.). The works of this time are marked by a seductive stylization, with slender limbs and harmonious proportions. The large statue of **Nakht** *is a good example.*

The wars of liberation against the Hyksos, invaders who had come down from the Near East one hundred and fifty years earlier, resulted in the New Kingdom (1550-1080 B.C. circa). The 18th dynasty produced some of the most captivating and moving sculpture in ancient Egypt such as **Hatshepsut and Sennefer** *or the statue of* **Akhenaton**, *figures imbued with grace and spontaneity.*

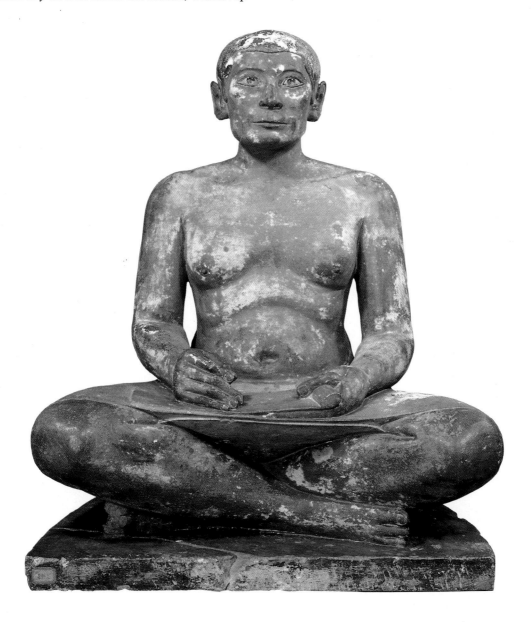

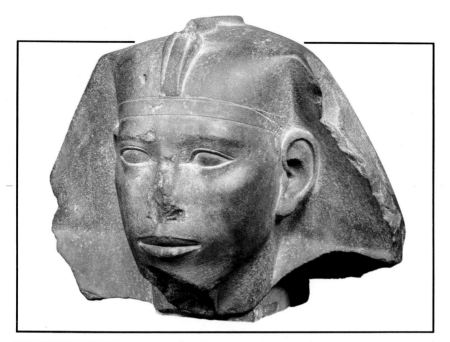

Head of Didufri

Archaeologists have encountered various problems in identifying this 4th dynasty pharaoh. Either the son, or brother, of Cheops, it is known that he was his direct successor and reigned only eight years before being dethroned.

The head on exhibit in the Louvre, 28 cm. tall and in red quartzite, was discovered by E. Chassinat during the excavations at Abu-Roach, where the pharaoh's pyramid was built.

On his head the king wears the nemes surmounted by the ureus. It is an exceptionally important work, not only as a portrait of the pharaoh, but also because of the great sensitivity and moving realism with which the melancholy features of the king are imbued.

Statue of the chancellor Nakht

Found during the excavations of Assiut, this statue belongs to the Middle Kingdom at the time of the 13th Dynasty, when Egypt, under the rule of the energetic Theban kings, had a period of great power and prosperity. As a consequence, its art too was stimulated and went on to new conquests. This surprisingly realistic statue, made of wood on which can still be seen traces of the original colour, represents the chancellor Nakht. It is in a rigidly frontal position, although there is a hint of movement in the left leg which is slightly forward of the body. The almost nonchalant position of the right hand, hidden in a fold or pocket of the long cloak, gives the figure an unusually natural and spontaneous quality.

Bust of Amenophis IV (Akhenaten)

Found by Henri Chevrier in what was once the great temple complex of Amen, this bust was part

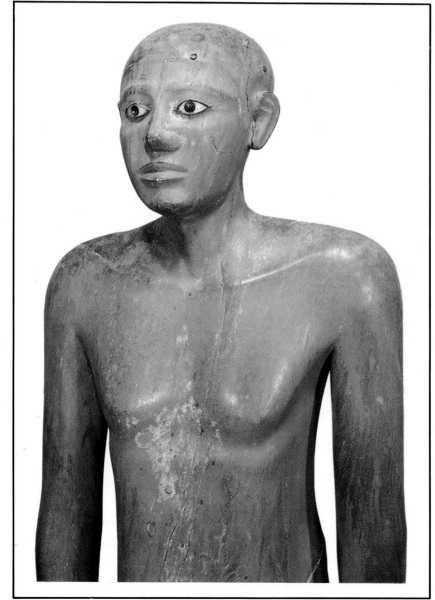

of one of the Osiris pillars in which the pharaoh so often had himself depicted. Shown with his arms crossed and holding the emblems of Osiris, the bust of Akhenaten is one of the loveliest expressions of the art of Tell el'Amarna in which ideals of simplicity and intimism replaced the search for a purely exterior beauty, with a stress on the actual physical characteristics of the sovereign.

Egyptian Art

Seti I with the goddess Hathor

This bas-relief in painted limestone dates to the early 19th dynasty and comes from the tomb of Seti I, with reason considered the finest in the entire Valley of the Kings.
The relief depicts the pharaoh Seti I, whose hand the goddess Hathor, dressed in a soft tunic decorated with beads, holds as she hands the king her «menit» necklace, a sign of her affectionate and benevolent protection.

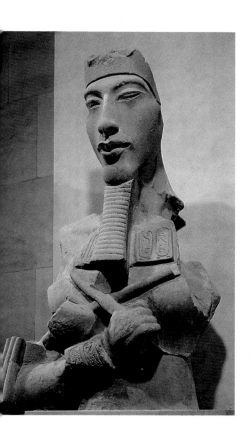

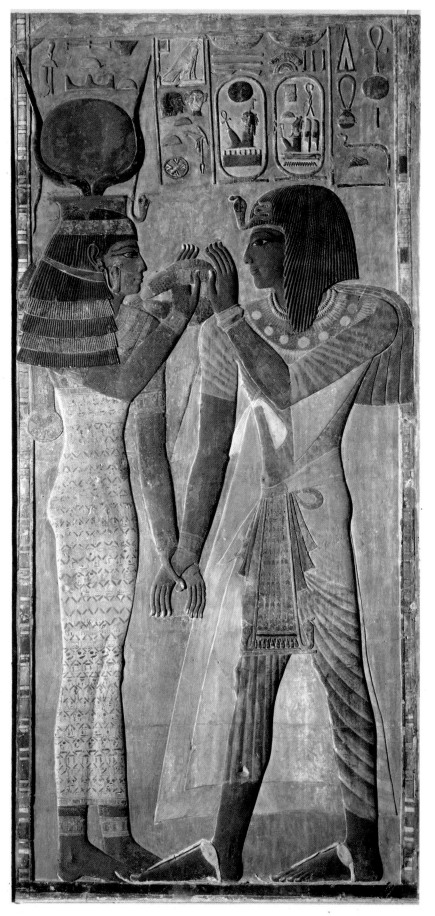

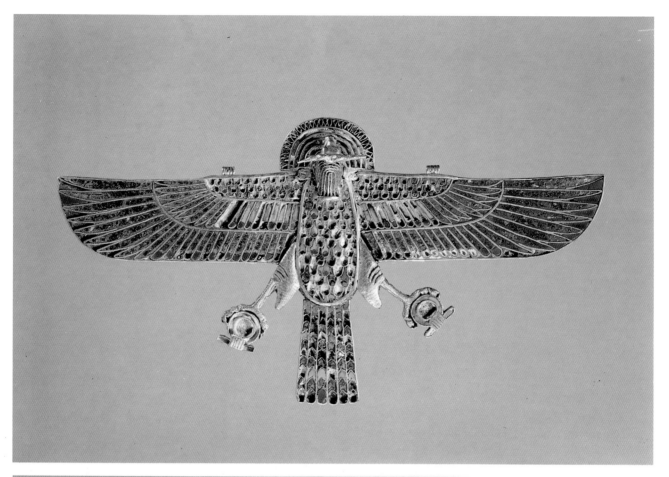

Pectoral of the 19th dynasty

A typical example of Egyptian goldwork, this pectoral of the 19th dynasty is in gold with inlays in carnelian, turquoise, lapis lazuli and green feldspar. The ram-headed vulture grasps the symbols of life (ankh) and eternity (shen) in its claws.

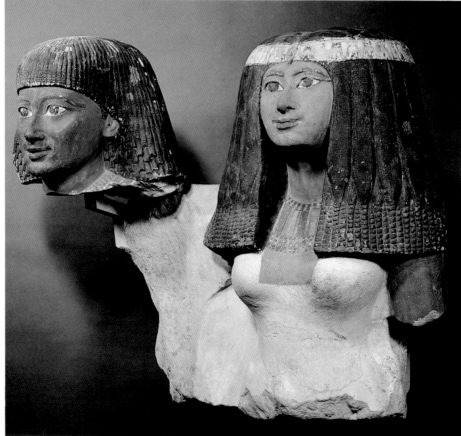

Hatshepsut and Sennefer

This fine group in painted limestone from the New Kingdom (1450-1400 B.C.) depicts Queen Hatshepsut and her vizier Sennefer. Both wear heavy wigs and the hint of a smile hovers on their lips.

GREEK AND ROMAN ANTIQUITIES

The section of Greek and Roman Antiquities is one of the oldest in the museum of the Louvre. The cult of «antiquity» goes back to the Renaissance. François I commissioned various copies in bronze of antique sculpture from Primaticcio for the palace of Fontainebleau.

Original Greek and Roman marble sculpture which Louis XIV had collected in Versailles formed the initial core of the museum collection. During the Revolution expropriations brought in further works, such as the fragment of the **Parthenon frieze** *requisitioned from the Count of Choiseul-Gouffier, to be followed by various acquisitions, such as the Borghese collection in 1808, unquestionably one of the most important (see the* **«Borghese» Gladiator***).*

The inauguration of the first «museum of An-

tiquity», in 1800, was marked in particular by the presentation of the works that Napoleon had requisitioned in Rome from the Vatican Museums and from the Capitoline Museum (above all the **Laocöon** *and the* **Apollo Belvedere***), which were returned to Italy in 1815.*

Some of the most famous masterpieces of which the department is justly proud were added to the collection in the nineteenth century: the **Venus de Milo***, given to Louis XVIII by the Marquis de Riviere; the* **Olympia marbles***, donated by the Greek senate in thanks for the services rendered by France in the course of the Greek wars for independence; the* **Victory of Samothrace***, sent by Champoiseau in 1863; and lastly the almost four thousand pieces of the Campana collection.*

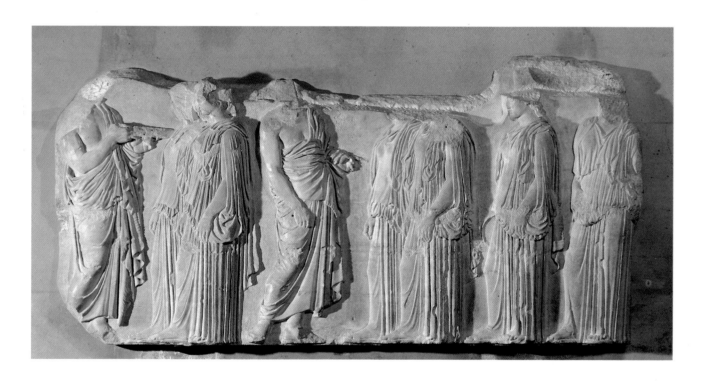

Greek Art

Frieze of the Panathenes

The most elevated expression of Ancient Greek culture and art (the Parthenon, on the Athenian Acropolis) must be ascribed to one of the greatest artists of all times: Phidias. The glory and the beauty of this temple are not determined solely by the elegant, symmetrical architectural elements, but also by the rich and exuberant plastic decoration: this last is today scattered all over the world. Phidias' «atelier» finished this frieze in the 5th century B.C.; it ran

around the naos of the temple, there depicting the annual procession during the celebration in honor of Athene, the patron goddess of the city. Even though dismembered and divided among various European museums (above all the Louvre and London's British Museum) the friezes lose nothing of their stylistic unity for being fragmented: depth is never accentuated and is always equal for all the groups of figures, all of which emerge to the same degree from the background. The draperies, as well, while quite different one from another, all demonstrate an equal rhythm and the same cadence as the slow procession of maidens, the Ergastines, carry their hand-woven peplum to the goddess.

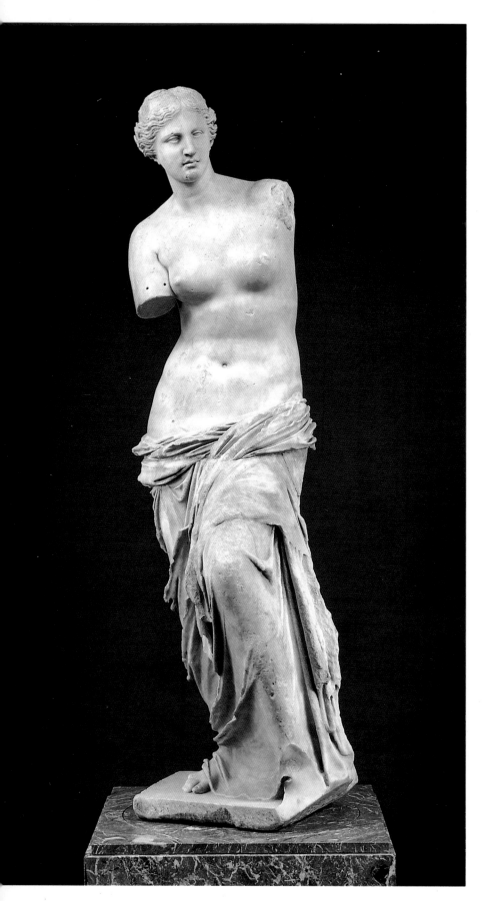

Venus de Milo

Discovered in 1820 by a peasant on the island of Milo in the Cyclades, this statue has come to be considered the prototype of Greek feminine beauty. Somewhat more than 6 feet high, with its arms broken off (no one has ever succeeded in establishing what the original position of the arms was), it belongs to the Hellenistic Age, that is to the end of the 2nd century B.C., but it almost certainly derives from an original by Praxiteles. Like the other works by this great sculptor, the figure is slightly off balance, as if resting on an imaginary support, which gives a delicate curve and twisting movement to the bust. Critics and art lovers have long gazed on the slender nude body of the goddess emerging from the heavy cloth of her cloak which is slipping towards the ground. The material of the statue itself, Parian marble, gives the goddess's body and skin a lightness worthy of the finest classical traditions.

Nike of Samothrace

Found in 1863 at Samothrace, with the head and arms missing (one hand was discovered in 1950), this work dates from about 190 B.C., a period when the inhabitants of Rhodes had a series of military victories against Antioch III. The Nike (or Victory figure) stands erect on the prow of the ship which she will guide to victory: the sea wind hits her with all its force, tearing at her clothing and pressing it to her body. The clothing here is treated in an almost Baroque way (which would fully justify the rather late date assigned to the work): it vibrates in contact with the Victory's body and flaps in the wind, which in turn pushes the Victory's arms violently backwards. About 9 feet high and made from Parian marble, this is without doubt one of the most important works of the entire range of Hellenistic statuary.

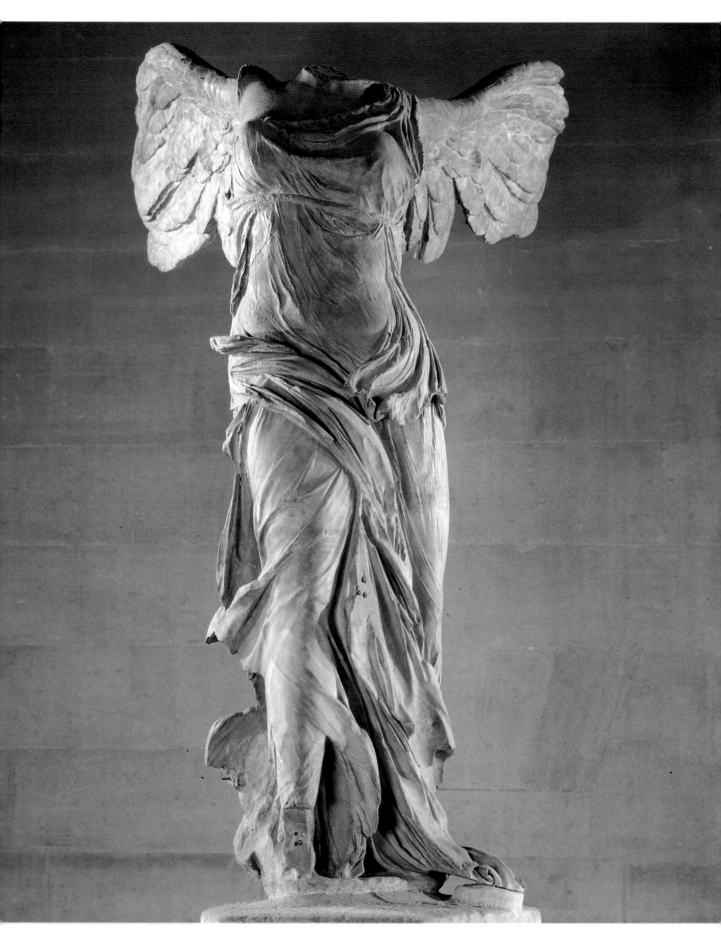

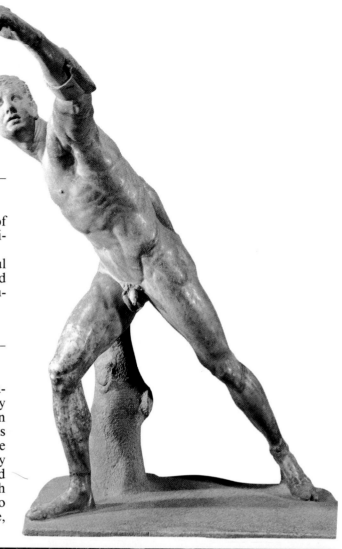

Agasias of Ephesus

The Borghese Gladiator

In its warriors, athletes and gods Greek sculpture of the first century B.C. exalts, one might say gloriously, the nude.

The Borghese Gladiator is composed on a powerful diagonal, which exalts the anatomical details and furnishes a vigorous interpretation of his heroic nudity.

Greek Art

Exaltation of the Flower

Most of the works of Greek statuary have unfortunately been lost to us, and we know them only through late imitations and Roman copies. But in this room are exhibited original archaic works (dating, that is, from between the second half of the 7th century and the beginning of the 5th century B.C.). Outstanding among them for its beauty and elegance is this Exaltation of the Flower, in which can barely be seen the gentle smiles of the two maidens, from whose arms, linked as if in a dance, the flower and fruit of the pomegranate emerge.

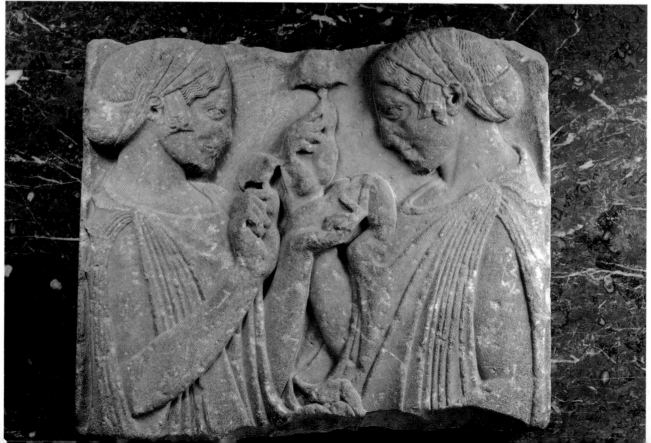

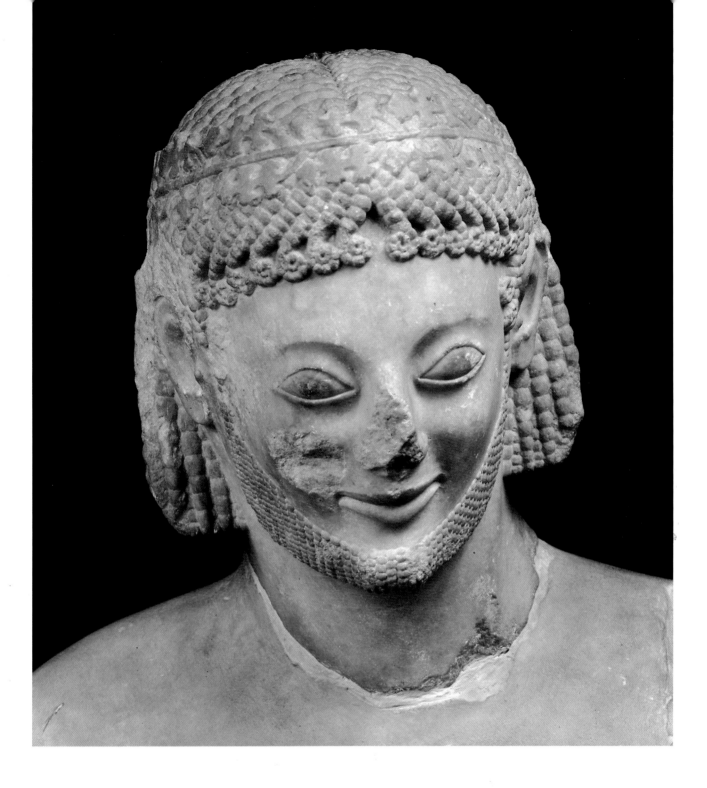

Greek Art

The «Rampin Horseman»

The head and torso of this marvelous rider, without doubt the winner of a race as witnessed by the laurel crown he wears on his curls, were discovered on the acropolis of Athens at different times. The various pieces, including a fragment of the horse, were re-united thanks to the intuition of Humphrey Payne.

Bequeathed to the Louvre by the collector George Rampin (who gave his name to the statue), this magnificent piece of sculpture dates to the times of Pisistratus (circa 550 B.C.), when the influence of Ionic art in Athens was at its acme. Traces of colour are still visible in the triangular eyes and the corners of the mouth are slightly raised in what has come to be known as the «archaic smile». But it is the way in which the head is turned slightly to the left on the torso that stylistically defines this statue and in its asymmetry heralds the decisive abandoning of the rigid law of frontality.

FRENCH PAINTING

The number and variety of French paintings in the Louvre make it the most important collection of its kind in the world. It is not however the oldest of the museum collections, for throughout the sixteenth century interest had centered on Italy, both for works of antiquity and for those by the great masters who dominated that century (Leonardo da Vinci, Raphael, Titian, etc.). The supremacy of the French school did not begin until Louis XIV.

THE PRIMITIVES
AND THE SIXTEENTH CENTURY

During the fifteenth century French painting gradually freed itself from the Gothic world. In Burgundy various artists such as Bellechose or Malouel (see 'La grande Pietà ronde') adopted a «Franco-Flemish» style where Northern realism went hand-in-hand with the charming stylizations of International Gothic art. In Avignon, where French and Italian influences intermingled, the result was an unadorned monumental style of which the **Pietà** is a supreme expression. This twofold Flemish and Italian influence is particularly evident in works such as the **Portrait of Charles VII** by Jean Fouquet or the **Magdalen** by the Master of Moulins.

When Charles VIII returned from his first expedition into Italy, France looked to the Peninsula. Called by François I to decorate his royal chateau of Fontainebleau, Rosso Fiorentino and Primaticcio created a school of Mannerist painting in France that was to dominate the entire century (see the **Portrait of Gabrielle d'Estrées**).

With the exception of the **Portrait of François I** by Jean Clouet, which was expressly commissioned for the royal collections, all these works found their way into the Louvre only later. Not until the nineteenth century did the curators of the museum and the public begin to take an interest in the early masters of French painting.

THE SEVENTEENTH CENTURY

Most of the various tendencies which appeared under the reign of Louis XII came from Italy (Valentin, Claude Vignon, Simon Vouet), but they were often reinterpreted in an extremely personal way (Georges de la Tour) or blended with other Northern influences (Louis Le Nain). When Louis XIV ascended the throne, all the talents were directed towards a type of classicism aimed at glorifying the greatness and power of the State, identified with the person of the Sun King. The prime moving force was Charles Le Brun, whose dictates influenced the arts and paved the way for the imposing decorative compositions commissioned by Louis XIV.

After François I, the greatest sovereign patron of the arts was Louis XIV. He unceasingly bought and commissioned paintings for Versailles and the other royal chateaux from his Court painters (Le Brun, Mignard) and precedent masters (Poussin, Claude Gellée). The king purchased about thirty works by Poussin, absolute point of reference for the academy, which are now in the Louvre.

THE EIGHTEENTH CENTURY

The beginning of the eighteenth century is characterized by the emergence of a reaction against the overly strict rules of Classicism. This reaction was embodied in the style known as «rocaille» or «rococo», a pleasing noncommitted art which began at the end of the reign of Louis XIV and which was affirmed under the Regency with Watteau's «fête galants». This art, of an extreme sensibility and poetry, was championed by diverse personalities such as François Boucher, favorite painter of Madame de Pompadour, Honoré Fragonard and Jean Baptiste Chardin, intimist painter of still lifes.

Unlike his contemporaries, Louix XV was not a collector. With the exception of a few acquisitions of works by living artists, the eighteenth-century collection preserved in the Louvre is due in great part to the donations which the great collector La Caze made to the museum in 1869 (among these **Gilles** by Watteau and the **Bathers** by Fragonard).

The end of the century was dominated by the neoclassic style, inspired by the recent discoveries in Pompeii and Herculaneum. Its greatest representative is without doubt David, and the Louvre owns his most outstanding and monumental compositions, such as the **Oath of the Horatii**, purchased from the Conte d'Angiviller, Director of Building under Louis XVI, or the **Coronation of Napoleon I**, which the emperor had commissioned in 1806 to commemorate his recent ascent to the throne.

THE NINETEENTH CENTURY

In 1818 the Restoration created the museum of Luxembourg, the first museum of contemporary art, where most of the great paintings of classic art were collected before reaching the Louvre (Girodet, Guérin, Gérard, Prud'hon), as were those by the new masters of Romanticism. Some of the greatest masterworks of «living» painting thus became part of the national collections, purchased directly from the Salon by the Conte de Forbin, Director of the Museums: **Dante and Virgin in Inferno** and **The Massacres of Scio** by Delacroix, as well as the **Raft of the Medusa** by Géricault. This policy of acquiring works by the Romantics continued under Louis Philippe. But it was not until the end of the century that the principal works of Ingres, the **Grande Odalisque** (1899) and the **Turkish Bath** (1911), made their entrance into the Louvre.

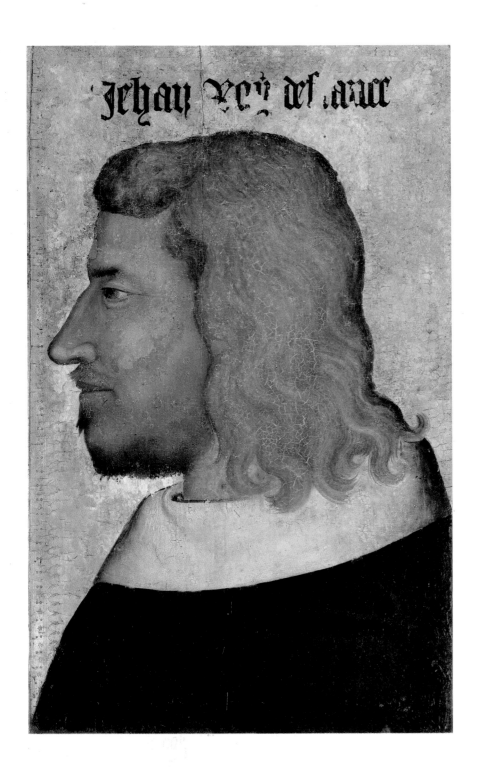

French painter (mid-14th century)

Portrait of John the Good

As the inscription on this small wooden panel, barely 55 cm. high, tells us, this is the profile of JEHAN ROY DE FRANCE, son of Philippe IV of Valois, who reigned from 1350 to 1364.

As the first individual easel portrait of unquestionable French origin, the work is unusually important. It has been suggested that the artist might be Girard d'Orleans, painter and valet of the king. The panel was one of a group of four portraits which included Charles V, Edward III of England and the emperor Charles IV.

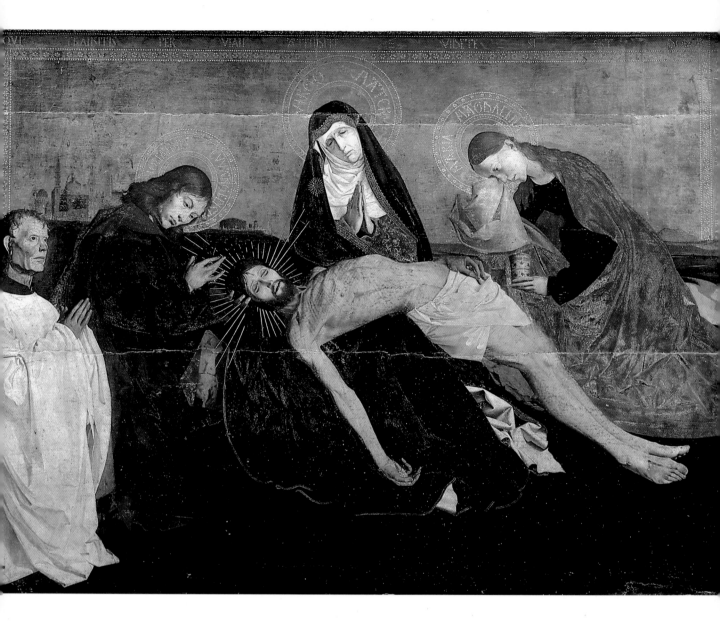

Villeneuve-lès-Avignon Pietà

This splendid panel, a genuine masterpiece of the Gothic International style, saved from a fire in 1793 and rediscovered in 1801 in the church of Villeneuve-lès-Avignon, has long presented a problem as to both its dating and attribution. Some critics have advanced the name of Enguerrand Quarton because of certain iconographical details, while others have said that it is the work of a Spanish painter, if not actually derived from Van der Weyden. The group stands out powerfully against the gold background which is the last remaining heritage of the Gothic style and will soon be replaced by compact blue skies. The figures seem to be derived from the numerous Pietà sculpted in ivory, wood and stone. The colour constrast is splendid, while the body of Christ is abandoned on the knees of the Virgin and St. John, his face remarkably ex-

pressive, removes the thorns from Christ's head. According to some critics, the figure on the left of the panel, representing the donor, is the canon Jean de Montagnac. A strong sense of pathos and profound emotion is created by the horizontal line of Christ's body, which tragically interrupts the static and compact group surrounding it. The sure sense of design and above all the expression of dignified grief seen on the faces of the figures make this panel one of the masterpieces of French painting.

Jean Fouquet (c. 1420-c. 1480)

Portrait of Charles VII King of France

This painting, hung in the Salon Carré where the marriage of Napoleon I and Marie Louise was held in 1810, is a justly famous work by Jean Fouquet,

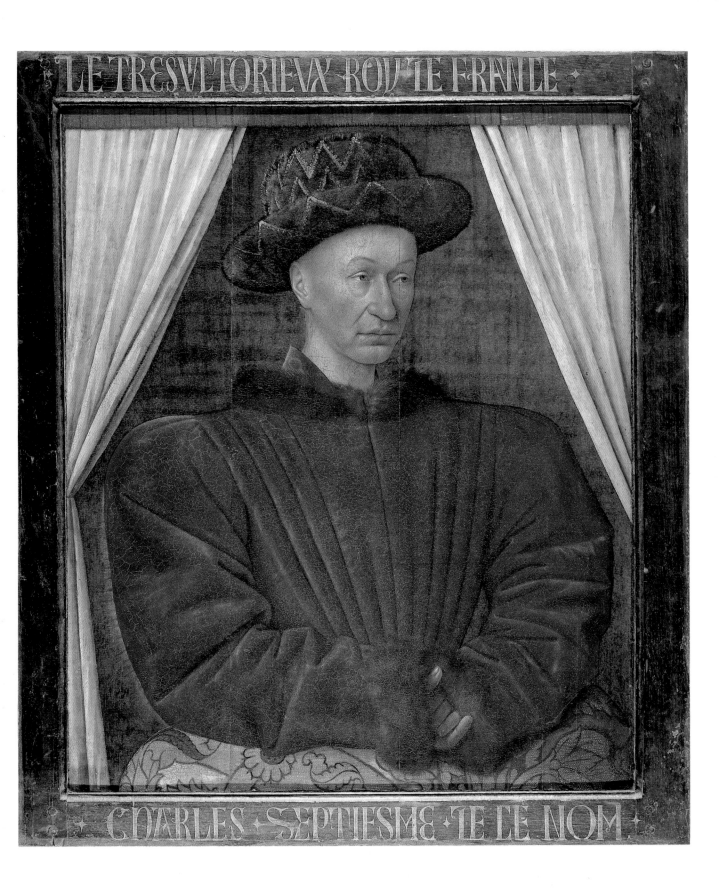

LE TRESVICTORIEVX ROY·DE·FRANCE

CHARLES·SEPTIESME·DE·CE·NOM·

and seems to have been done in about the year 1444, that is shortly after the painter's trip to Italy. The painting was given by the king to the Sainte Chapelle of Bourges, where it may have remained until 1757, the year in which the church was demolished. It entered the collection of the Louvre in 1838. It offers a three-quarter view of the king, richly dressed and standing out clearly against the background.

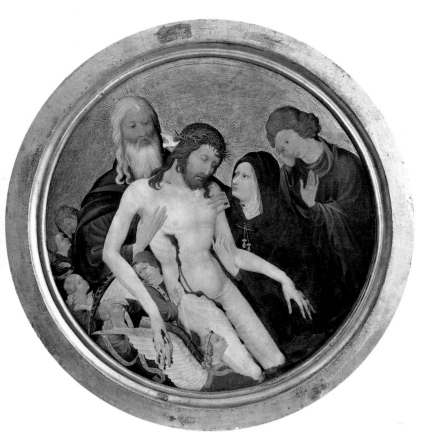

«La grande Pietà ronde»

Little is known of this painter from Gueldre who worked in Paris for the queen, Isabella of Bavaria, and who became court painter to the Duke of Burgundy in 1397, after Jean de Beaumetz and before Henri Bellechose. Two fundamentally important works are assigned to him with certainty: a *Virgin with Angels* and this *Pietà*, painted at the end of the 14th century for Philip the Bold, whose coat of arms is to be found on the back of the panel. The feeling for drama and intense pathos that characterizes the equally famous *Pietà* of Avignon and furnished by the broken body of Christ is no longer there. The muted sorrow expressed here is more intimate and restrained and the great refinement of line undoubtedly reflects the lesson of Italian art in Paris.

Jean Clouet (ca. 1480-1541)

Gala portrait of François I

A study for the head of François I, here shown in gala dress around 1525, is preserved in the Museum of Chantilly. Despite the rich habit and the tapestry in the background, one cannot help but noticing the shrewd and determined expression of this king, considered one of the most magnificent and intelligent of the French sovereigns. Jean Clouet had been court painter since 1516 and left us a gallery of portraits of the most illustrious figures of his time, profound character studies which make him the father of the psychological portrait in France.

Master of Moulins (active 1480-1504)

St. Magdalen Presents a Donor

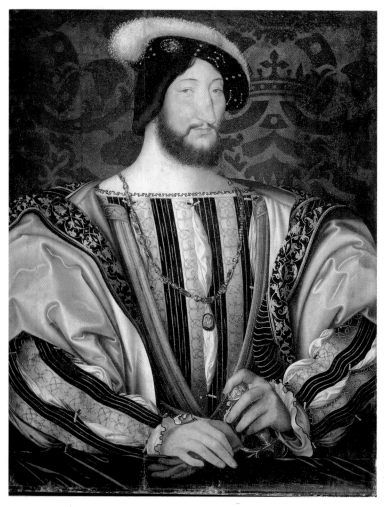

Possibly painted between 1490 and 1495, this panel was probably the left wing of a diptych or triptych. The donor is the natural daughter of Philip the Good, Magdalen of Burgundy, who was married to Bompar de Laage and who died before 1495. The artist of this panel was without doubt the greatest French painter of the late fifteenth century. Identified with Jean Hey, he was trained in the Low Countries as revealed by the profound Flemish influence in his art. His portraits have what might even be called a sculptural solidity, where the sure firm line delineates the features and captures the gestures with a grace that, however, remains exquisitely French.

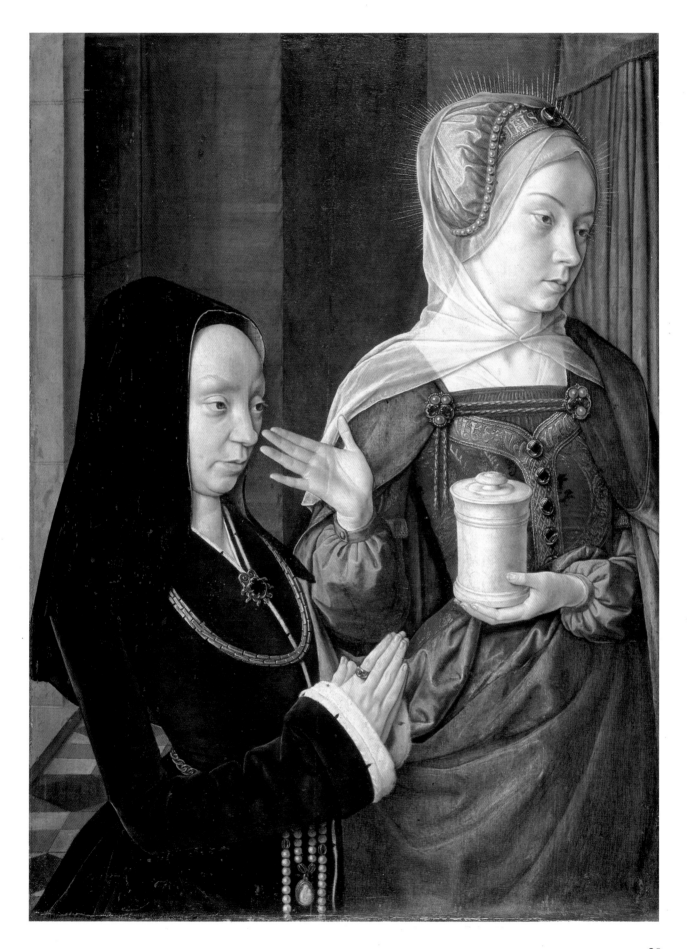

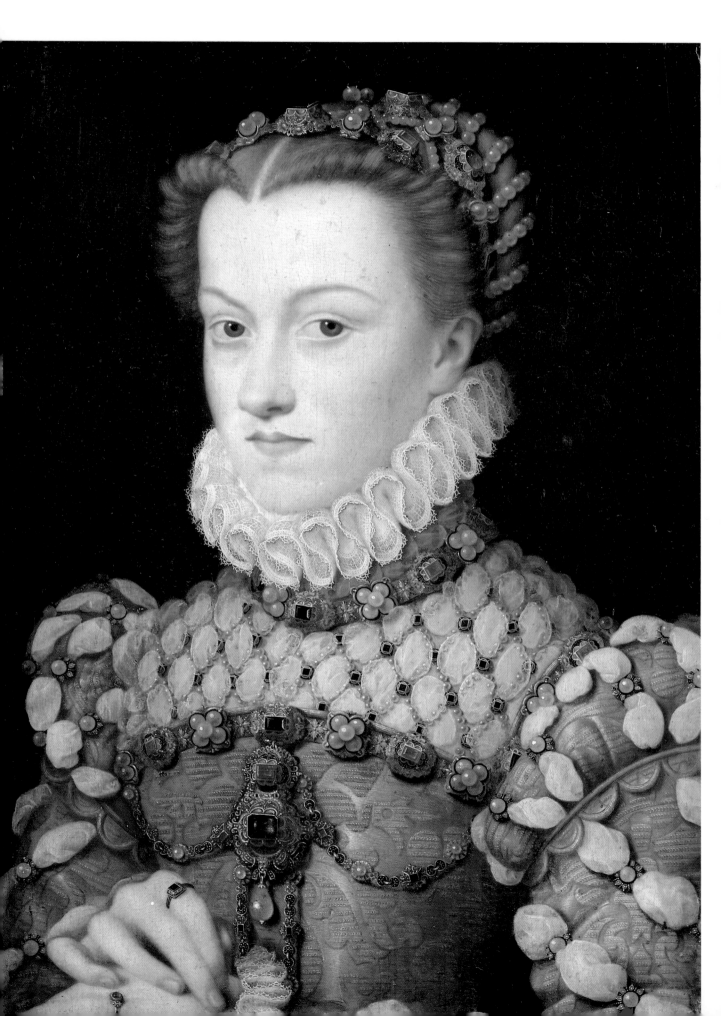

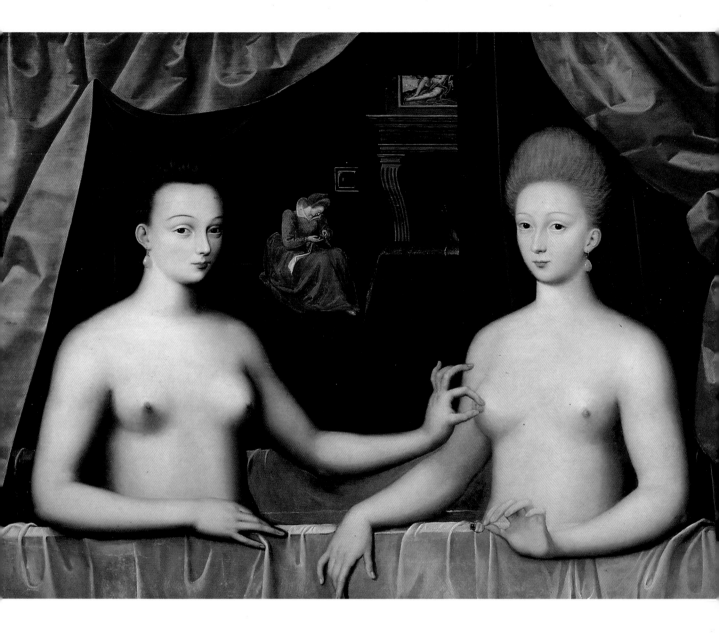

François Clouet (mentioned 1536-1572)

Portrait of Elizabeth of Austria

Son of the other great painter, Jean Clouet, François succeeded his father as court painter in 1540. In this portrait, painted with a sure mastery of line and a particularly delicate use of colours, the artist depicted the daughter of the Austrian emperor, Maximilian, who on 27 November 1570 married the king of France, Charles IX.

School of Fontainebleau

The Duchess of Villars and Gabrielle d'Estrée

The unmistakeable style of Clouet is fairly obvious in this work, attributed to the School of Fontainebleau, which can be dated at around the years 1594-1596. This is another example of the portrait, a genre which by then had become a fashion much patronised in court circles. Between the heavy curtains behind the two women a glimpse of domestic life is given: a woman sitting beside the fire, busy with her sewing. The two female figures, whose portraits have been painted while they are taking a bath together, are two sisters, Gabrielle d'Estrée and the Duchess of Villars. The latter, with a symbolic gesture, is announcing the future birth of the son of Gabrielle, who was the mistress of King Henry IV.

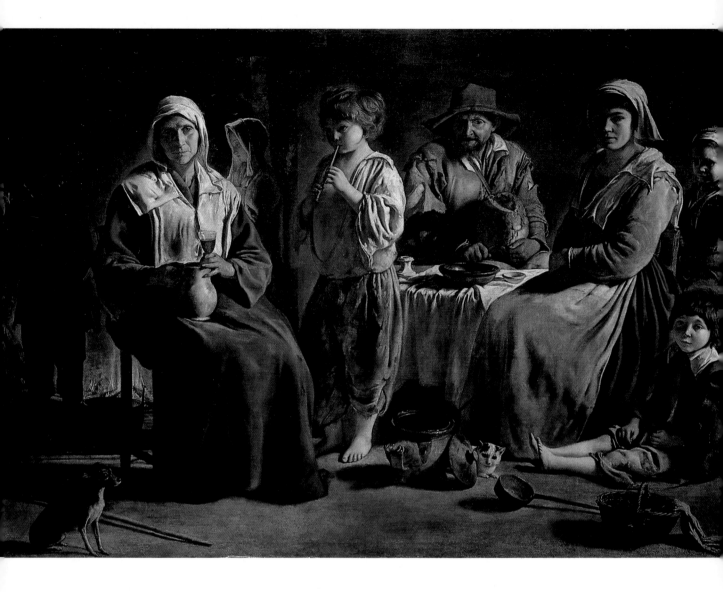

Louis Le Nain (1593?-1648)

Peasant Family

Of the three Le Nain brothers, Antoine, Louis and Mathieu, Louis is considered without doubt the best artist. A painter who specialised in portraying rustic scenes and lovingly recorded the world of the humble people, far from the luxuries of the court, he too displays in his work a distant echo of the luminous technique of Caravaggio, painting dark interiors with a minimum of illumination. But what was a metaphysical, supernatural light in Caravaggio is transformed in Le Nain's work into the quiet glow of the fireplace. The members of this poor peasant household seem to have been posed in front of an imaginary photographer, each one having left off his normal activity. The painter, more than ever poetic in this work, captures the tiniest details of the room with affection and accuracy, dwelling on it with a feeling of lament for a pure and simple world.

Georges de la Tour (1593-1652)

Mary Magdalene with Oil-lamp

The artistic formation of George de la Tour, who was born at Vic-sur-Seille and died at Lunéville, was rather complicated. He preferred compact, closed volumes and a pure geometrc style, forms immersed in the shadows and revealed by skilfully placed rays of light. It is obvious that he learnt much from Caravaggio. According to some critics, the Caravaggio influence derived from a trip to Rome which the painter made around the year 1612 o 1613; other critics believe the technique came from the artist's contacts with the works of Gherardo of the Nights, another painter fascinated by the problem of light and shade which he resolved with surprising ability. This painting, done towards 1635 or 1640, is full of a sense of desperate solitude, expressed in the way Mary Magdalene stares abstractedly at the tiny flame, which seems to be consumed before our very eyes, and in her almost mechanical way of caressing the skull in her lap.

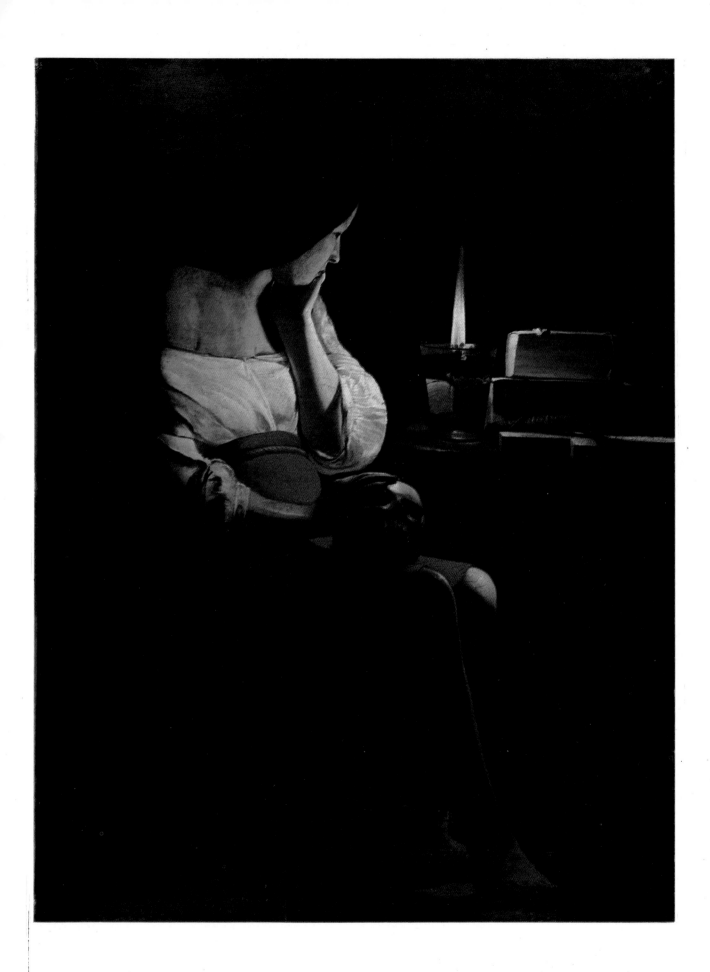

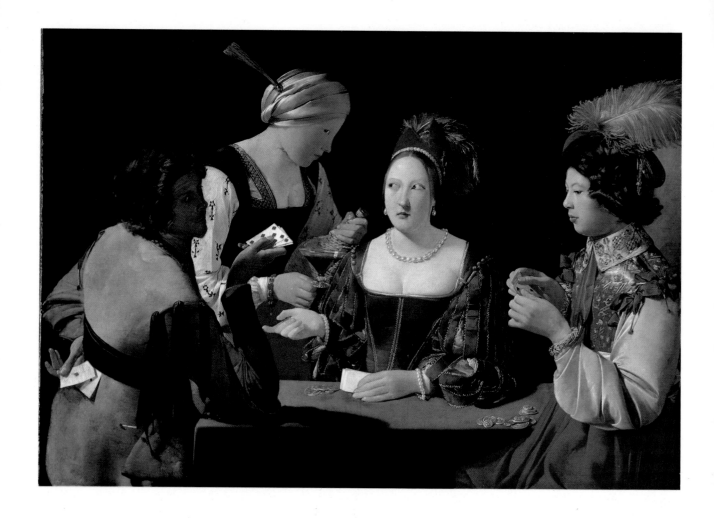

The Cheat

This is the last of the so-called series of «day scenes» which included many works by the artist who there-after, in the last ten years of his life, devoted himself to a series of paintings known as «night scenes», in which the idealized figures stand out against barely lighted surroundings, often illuminated by no more than the warm unreal light of a candle.

Two themes appear in this rich composition – that of the cheat and that of the courtesan. The light which falls from one side onto the woman's head and shoulders and the theme itself of the picture recall the work of the school of Caravaggio.

Nicolas Poussin (1594-1665)

Rape of the Sabine Women

Born in France, Poussin passed many years of his life in Rome, where he died. Here the painter came into contact not only with the Baroque world, which was slowly coming into being, but also with the world of the late Renaissance, which still survived in the works of Raphael in the Vatican. Poussin pre-ferred to paint large works of a mythological or his-torical sort, like this Rape of the Sabine Women, of which he also painted another version, now in the Metropolitan Museum of New York and datable at around 1637, that is some years after the work in the Louvre. Typical of Poussin's painting is the sense of agitation which can be felt between the figures, so strikingly framed in the motionless setting of classi-cal architecture.

The Inspiration of the Poet

Still another purely classic episode for Poussin, who painted this picture, which belonged to Cardinal Mazarin, between 1628 and 1629. It depicts a poet dear to the ancient world, Virgil, inspired by Apollo and the muse Calliope.

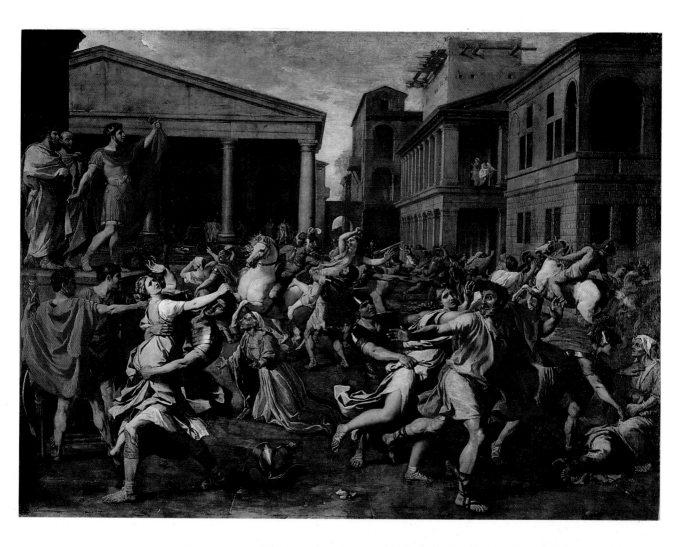

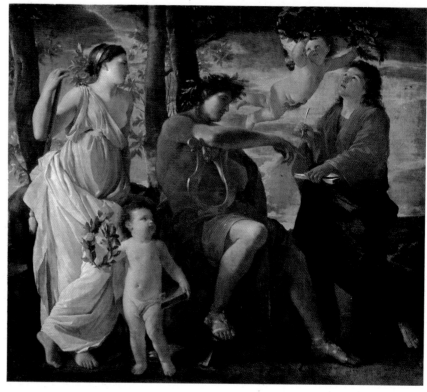

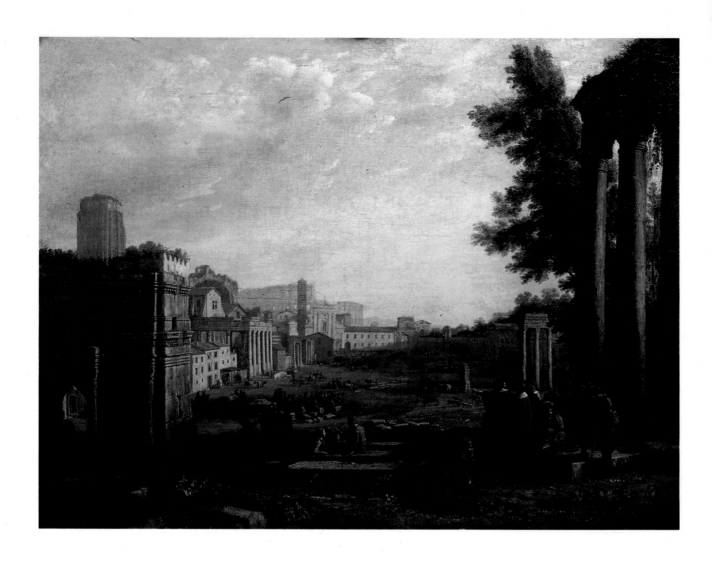

Claude Lorrain (1600-1682)

Campo Vaccino in Rome

Like Poussin, Claude Gellée, better known by the name of Claude Lorrain, also lived for many years in Rome. His Roman landscapes are full of a warm, golden light, typical of those sleepy afternoons when the shadows grow to enormous lengths on the rough terrain of the Roman Forum. With the eyes of one passionately interested in the antique world and its remains, Lorrain allowed his gaze to rest on a broken pediment, an arch covered at the top with moss, columns lying full-length on the ground, overturned capitals. His way of seeing nature and interpreting the landscape was thus completely different from that of Poussin.

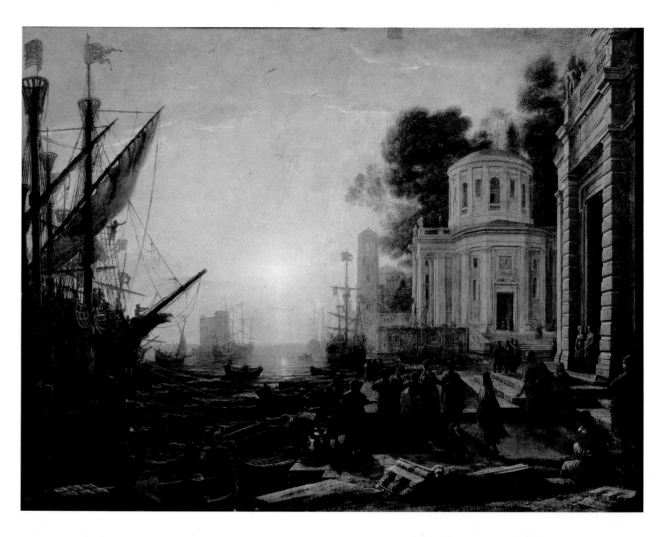

The Disembarkation of Cleopatra at Tarsus

Painted for Cardinal Angelo Giorio in 1642, this canvas is a true masterpiece of vast perspective and spacial unity. The true subject of the painting is once more the representation of water, a theme always close to the heart of the painter.

Philippe de Champaigne (1602-1674)

Portrait of Robert Arnauld d'Andilly

The portraits of various members of the family of Arnauld d'Andilly, closely connected to the events involving Jansenism, were painted by Philippe de Champaigne. In this picture Robert, who in 1646 retired to Port-Royal-des-Champs, the cradle of Jansenism in France, is shown near the close of his life. His burning glance and the gesture of his hand mirror the personality and cool and collected strength of his character.

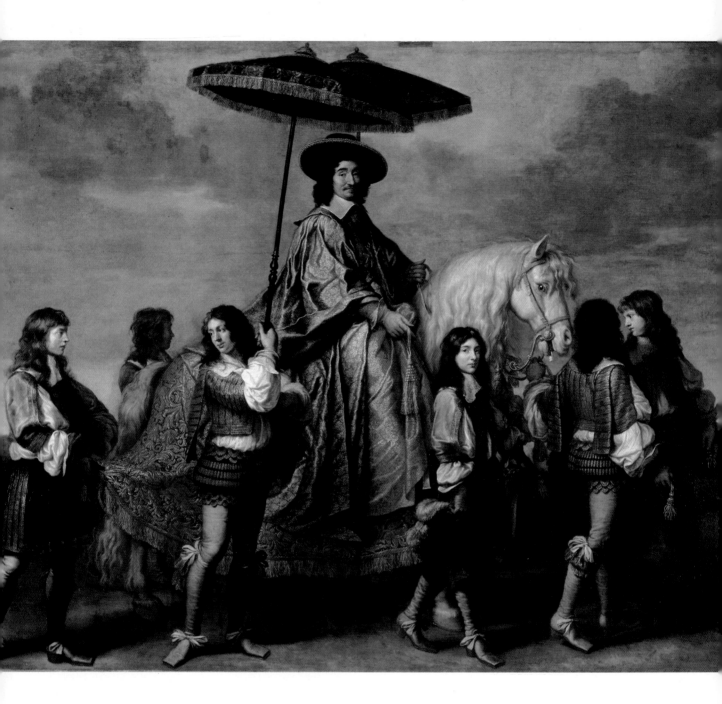

Charles Le Brun (1619-1690)

The chancellor Séguier

An architect as well as painter, Charles Le Brun was head of the French Academy during the reign of Louis XIV. In fact he decorated most of the Palace of Versailles and the sketches for its plastic decorations are also his work. His style clearly takes its inspiration from the Italian artists of the 16th century, in the richness and opulence of the clothing, in the stately quality of the poses and in the rich, warm colour. Here Le Brun has portrayed Pierre Séguier, Chancellor of France and the painter's patron during his youth. The painting may have been done towards 1655 or 1657.

Hyacinthe Rigaud (1659-1743)

Louis XIV King of France

The archetype of royal majesty is represented in this particularly impressive portrait. It was the year 1701, the king was 63 years old and had been governing to all effects for forty years, having experienced glory and adversity, deep sorrow and joy. Despite the features which have grown heavier with age, there is no sign of good naturedness in his cold and dissembling glance and there is no sign of relaxation in the pose.

This stiff figure in his gala coronation gown has nothing in common with the sovereign depicted in the early portraits of his radiant youth.

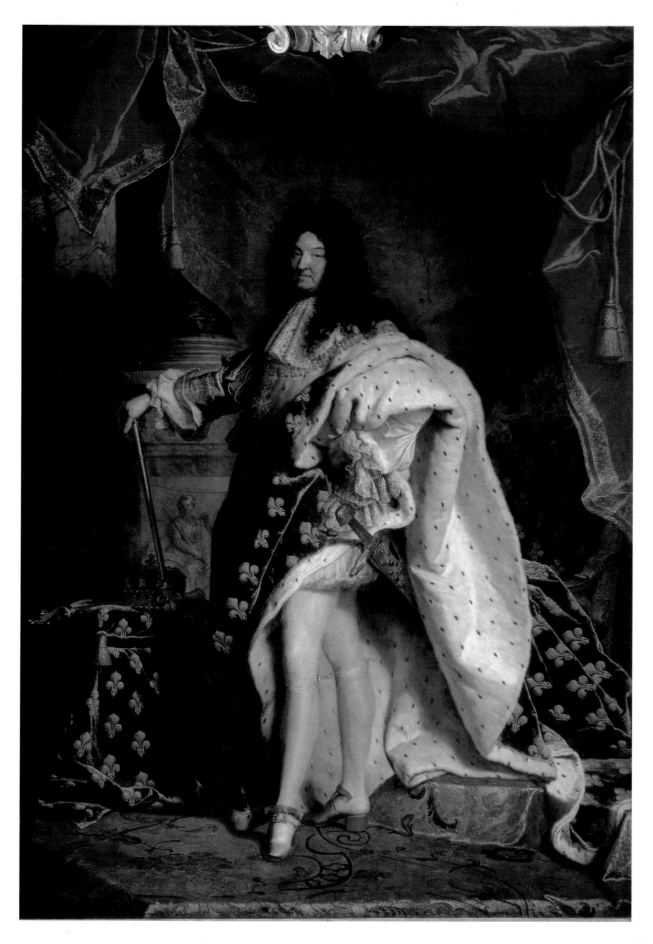

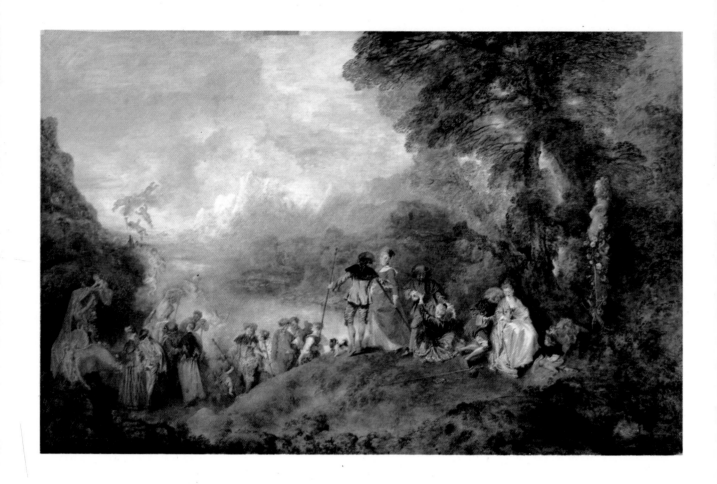

Antoine Watteau (1684-1721)

Embarkation for the Isle of Cythera

This work of Watteau, difficult to interpret and much discussed, was presented at the Royal Academy on August 28, 1717: in 1795 it became property of the National Museum and later of the Louvre. The interpretation of the canvas is, as we have said, rather complex. Some have seen a celebration of Love, some the representation of the games and customs current with the elegant, refined society of the Regency period. Watteau was the supreme interpreter of this society, representing as he did the courting games, the pleasures and the feelings of the various characters with a colouring which, although recalling the great Venetian masters (above all Titian and Veronese) is not certainly without a suggestion of Rubens' robust brushstroke.

Gilles

If Rubens is the highest expression of the Baroque Age, Watteau is without doubt his equivalent in the era of Rococo. Rather than the unleashed passions in the great Flemish painter's work, Watteau depicts an intimate, idyllic world. Done around 1717 or 1719, this work represents Gilles or Pierrot, a character from the Italian Commedia dell'Arte, and the figures in the background also belong to the popular theatre. The painting was acquired in 1804 by Baron Vivant-Denon from the art dealer Meunier, who had it displayed as a signboard for his shop in Place du Carrousel. In 1869 it was bequeathed to the Louvre. One critic, Mantz, has suggested that the work is a portrait of the comedian Bianconelli.

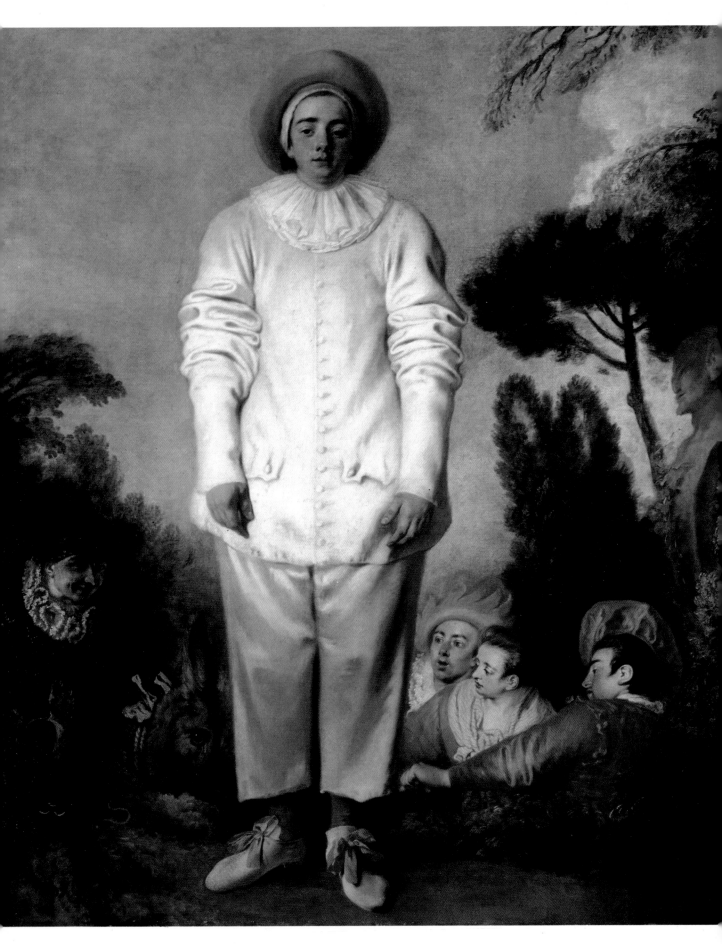

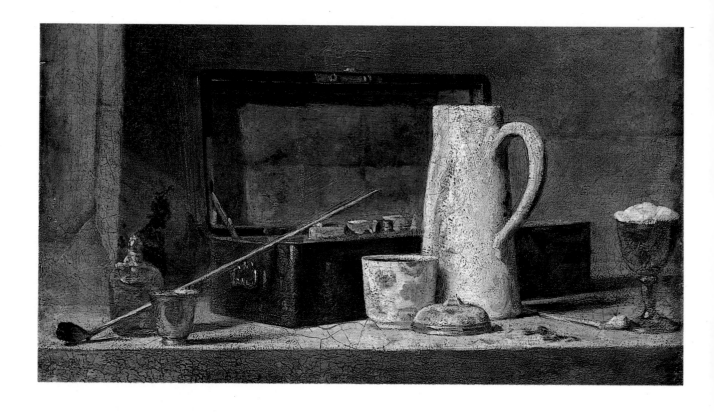

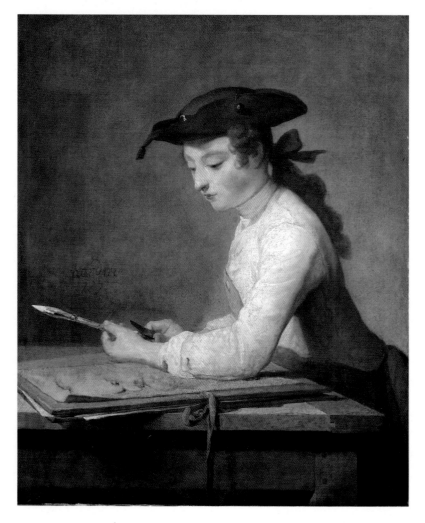

Jean Simeon Chardin
(1699-1779)

**Still Life with Pipe;
The Young Draughtsman
Sharpening his Pencil; The Grace**

Under the influence of the Enlightenment, daily reality, the small things of life, everyday experiences finally replaced the other-wordly myths which had up to then dominated the field of art.

Chardin's art falls into this current and, in the reproduction of still lifes and bourgeois interiors, he became one of the best-liked painters of the eighteenth century. Throughout the course of his artistic production Chardin remained faithful to a genre which was gradually being neglected for the great historical and mythological themes. His idiom is bourgeois, just as the themes he chose were bourgeois: the repertory was limited to interiors reminiscent of and inspired by Flemish works, the figures and objects of everyday life.

The Still Life with Pipe, dated 1760 or 1763, is sober and essen-

tial, the objects are arranged according to a rigid criteria, each suspended in its own precise and determined space, ideally joined to each other, yet each equally valid in its reality.

The other two paintings are extremely fresh in their inspiration; representing two ordinary moments of everyday life: a boy busy sharpening his pencil, and a woman setting the table while her two children say grace: compared to the frivolous elegance of the Rococo, Chardin's art strikes ud for its absolute sincerity.

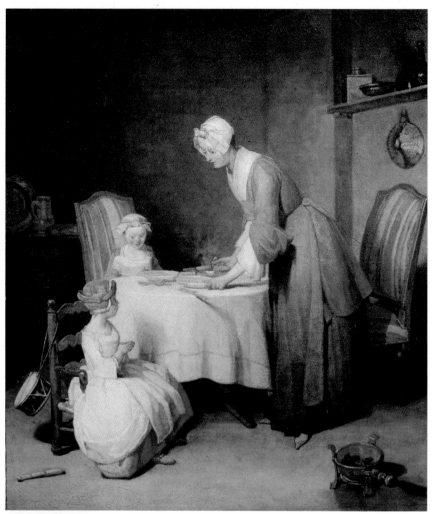

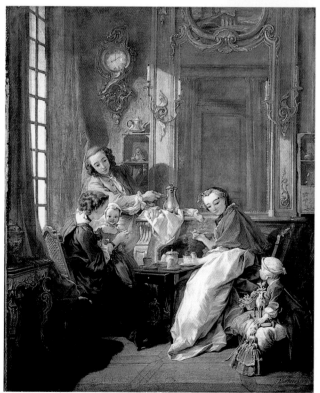

François Boucher (1703-1770)

The Morning Meal

Never has a Louis XV room been described with such precision, such loving care for detail. The fact that François Boucher rarely painted such scenes of bourgeois intimacy, accustomed as he was to illustrating quite other surroundings and situations in the brilliant court life which moved around Madame de Pompadour and Louis XV, makes it even more unusual. This «rocaille» interior is unquestionably in the painter's own apartment, in rue Saint-Thomas-du-Louvre, and the family shown includes the artist's 26-years old wife and their two small children.

43

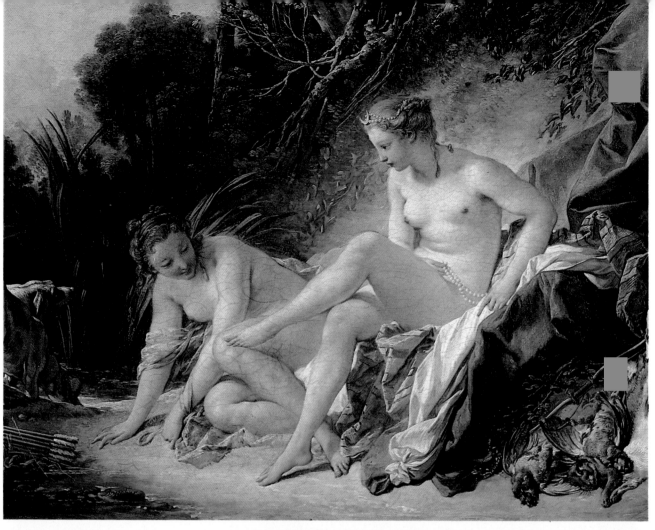

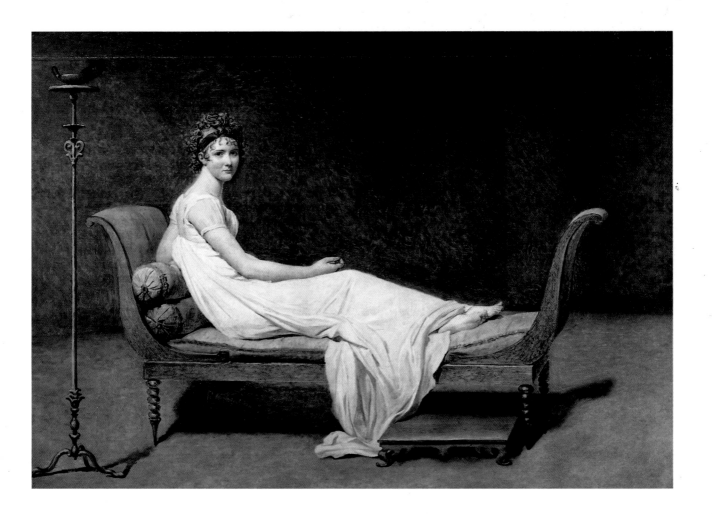

Diana Resting after Leaving her Bath

A typical representative of the French Rococo style, Boucher was a court painter at the time of Louis XV and enjoyed the patronage of Madame la Pompadour. His is a festive, refined art, full of the joy of living. Rather than war-like divinities, he preferred painting more seductive figures from mythology, and this is why the many paintings of Venus which he left have been called «boudoir Venuses». The female bodies which he loved to paint are perfectly proportioned, in the triumphant nudity of adolescence, warmed by his tenuous and delicate colours.

Jean-Honoré Fragonard (1732-1806)

The Bathers

Fragonard was the best-known and best-loved representative of French Rococo: a pupil of Boucher, he was greatly influenced by the style of Rubens in the sensual quality of his colour and the fullness of his forms. This canvas, perhaps painted in the period which followed the artist's first trip to Italy (from 1756 to 1761) and given to the Louvre in 1869, may have been done as a companion piece to the other work of the same subject, now part of a private American collection. The painting is a sort of hymn to life, sensuality and joy, but in forms which have become almost immaterial and ethereal.

Jacques-Louis David (1748-1825)

Portrait of Madame Récamier

This oil-on-canvas of Madame Récamier at age 23 is dated 1800: a period of David's production, that is, which is usually considered to be rhetorical and commemorative. His portrait painting, nevertheless, is an exception. This is an image of great purity, acute psychological introspection and warm humanity. The background is indistinct, intentionally dark so as to show up the beautiful figure of the woman as she delicately turns her head toward the spectator. Neither are the colors cold and metallic any longer: they have acquired a warm, intimate tone.

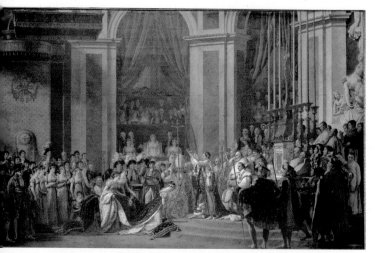

With the coming of the French Revolution and the great changes which it brought in every field, artistic canons too were overturned. Rococo elegance was banished, and it was the Academy with its official tastes which now dictated the rules. The new era required its own interpreter and found him in Jacques-Louis David, who had been in sympathy with the revolutionaries and now became a fervent admirer of Napoleon, at whose side and under whose patronage he worked with great energy. After numerous sketches and drawings, David painted this enormous canvas with a surface of 580 square feet, representing the coronation of Napoleon which took place on 2 December 1804 in Nôtre-Dame. David worked on it from 1805 to 1807, with the help of his pupil Rouget as well, painting no less

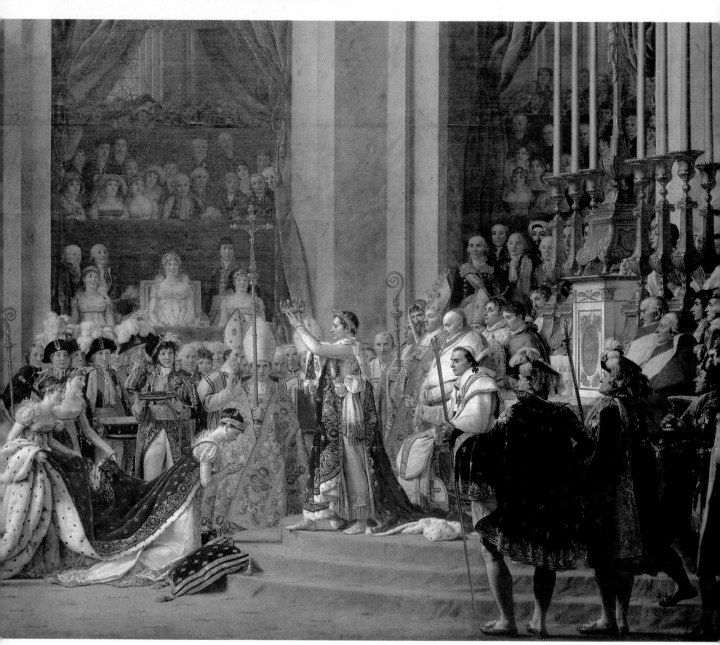

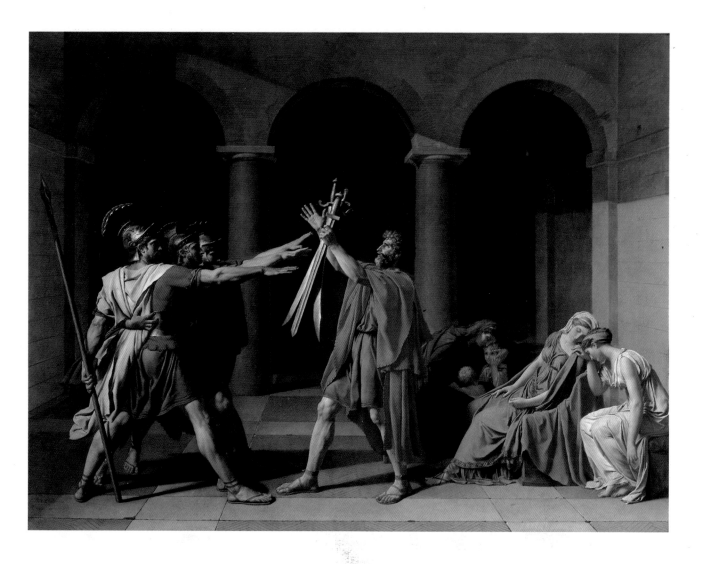

than 150 portraits, all of them vivid and solemn images. This work, which confirmed David definitively as the most important painter of the new Empire, displays an outstanding sense of equilibrium in its composition, besides solemnity and nobility of expression. One might say that each image and each figure (all historically recognisable) constitutes a portrait in itself because of the accuracy with which they are conceived and the coherency with which they are realised.

The Oath of the Horatii

Fascinated by the staging of Corneille's *Horace*, which he had seen late in 1782, David decided to dedicate a large painting to this theme. In preparation he went to Rome, for it was only there, in direct contact with Antiquity, that he could find the concentration and cultural background he needed to carry out his plans. The period between October 1784 and August 1785 was consecrated to the painting: the impact of this work on the critics and the

Roman public which flocked to see it was sensational, and David himself wrote: «In Rome one speaks of nothing but French painting and the Horatii».

Actually while this great painting is the key work of neoclassicism it is also something more: it is a political manifesto, an authentic declaration of principles, an exaltation of republican virtues.

The action (a «Norman» oath with two of the Horatii swearing with their left hands) takes place before a portico with three arches, each of which separately frames one of the three groups in the scene: the three Horatii, the old father, the prostrate family. The action centers on the left fist of the father who grasps the swords of his sons in a vigorous clenched gesture: the focal point of all the perspective lines.

It is true that David was inspired by Antiquity, above all in the sculptural majesty of the figures. But it is a mistake to interpret this composition with its extreme formal rigor as a solemnly erudite vision of the past. In his exaltation of patriotic virtues, David here anticipates the times: the ideas of the revolution are already at the door.

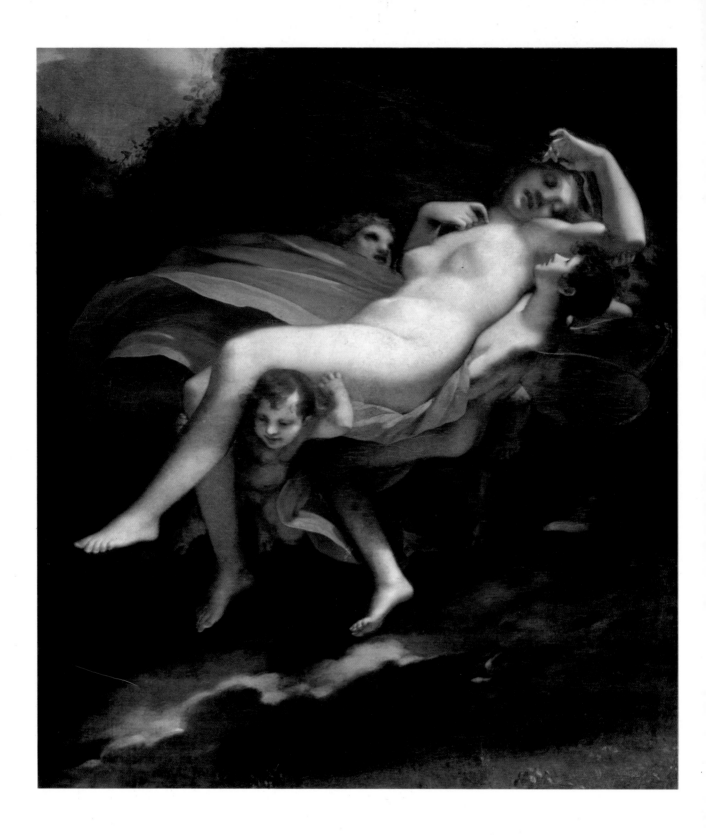

Pierre Paul Prud'hon (1758-1823)

The Rape of Psyche

As were many painters of his time, Prud'hon is of neoclassical formation: he feels the influence of 17th-century painting rather strongly. This work clearly recalls Guercino; more still, however, the slow, continuous movement of the forms, the sensuality of the composition and the contrast between the white of Psyche's body and the billowing yellow cape recall Correggio. Prud'hon, in rejecting the historical-rhetorical themes then in vogue in favor of allegory and mythology, is a precursor of Romanticism.

Théodore Géricault (1791-1824)

The Raft of the Medusa

Painted and exhibited in the Salon in 1819, this canvas takes its inspiraton from a tragic historical event: the «Medusa» was a French frigate which in 1816 was carrying settlers to Senegal when it was shipwrecked during a storm because of the inexperience of the captain. Most of the 150 passengers died; the few who were saved clung to a life-raft and drifted aimlessly in the immensity of the ocean, torn by episodes of human violence and ferocity.

Géricault relates the story with a crude realism, to which the violent contrasts of light and shade, learnt without doubt from Caravaggio, contribute. Géricault captured on canvas the moment in which the shipwreck victims sight a sail on the horizon, and a tremor of life and hope seems to run through the raft which has known horror and death. The whole composition, with its diagonal line, presents a mass of interlocked, disjointed bodies and dramatic, hallucinated expressions. Truly splendid, the figure of the old man holding up a now dead body, absorbed in his grief and desperation (which are the same grief and desperation of all the others), as solemn and dignified as a figure from Greek tragedy.

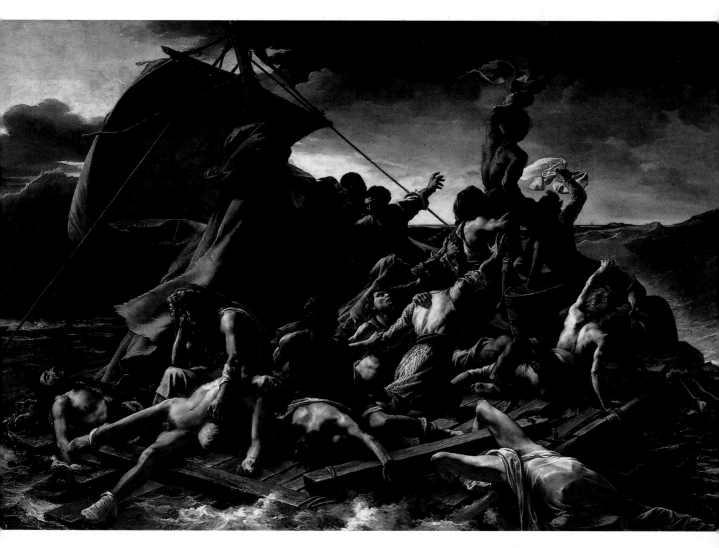

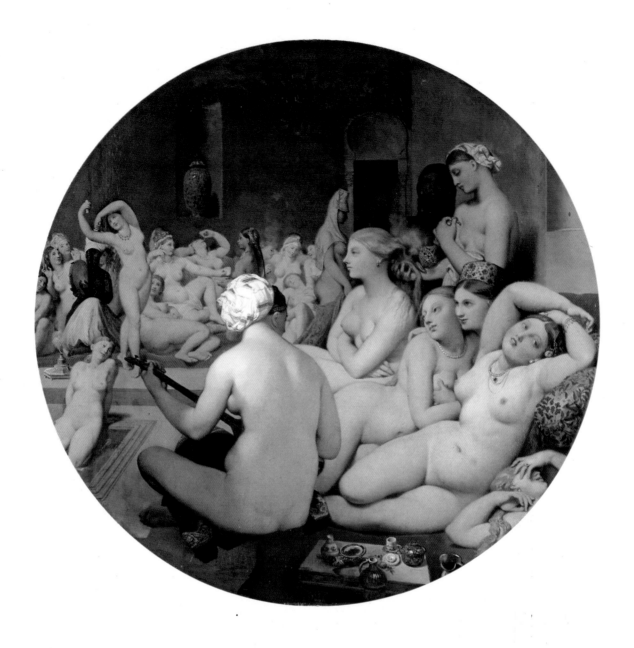

Jean-Auguste Ingres (1780-1867)

The Turkish Bath

This famous painting by Ingres, the inspiration for which certainly came from the description of a harem in the Letters of Lady Montague, was originally framed and was the property of Prince Napoleon. On the insistence of his wife, who considered the picture unbecoming because of the large number of nudes which it contained, Napoleon in April 1860 returned the work to Ingres who kept it in his studio until 1863, working on it continually and modifying it in various ways, one of which was to change it into a tondo. The Turkish ambassador in Paris, Khalil Bey, bought it for 20,000 francs, and late it came into the hands of Prince de Broglie, finally reaching the Louvre in 1911. The painting can be considered a synthesis of all the experiences which Ingres had begun sixty years before: the draw-ing technique has become extremely slender and sinuous, the colour limpid, almost dazzling. A continuous line unites all the bodies to each other, immersed as they are in their sensual surroundings with a heavy atmosphere of Oriental perfumes. The nude bodies of the women, although they are higly abstract, are touched by an emotional tremor which renders them extremely natural.

The «Grande Odalisque»

The pure play of lines so dear to Ingres clearly comes to the fore in his isolated female nudes, as in this Odalisque languidly resting on silk cushions.
It is as if the spark of life had suddenly entered an antique statue and the body become real living flesh: the figure quivers with subtle emotions and is endowed with a palpable humanity.

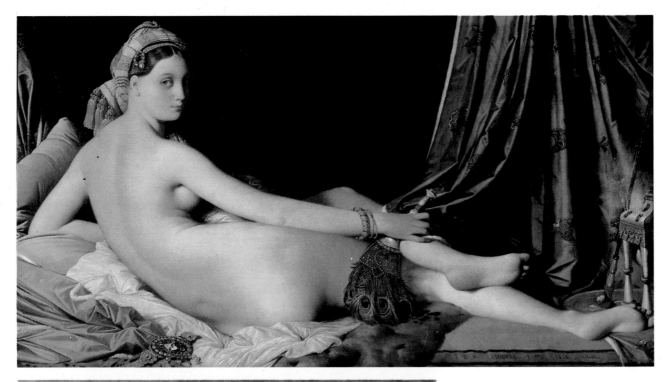

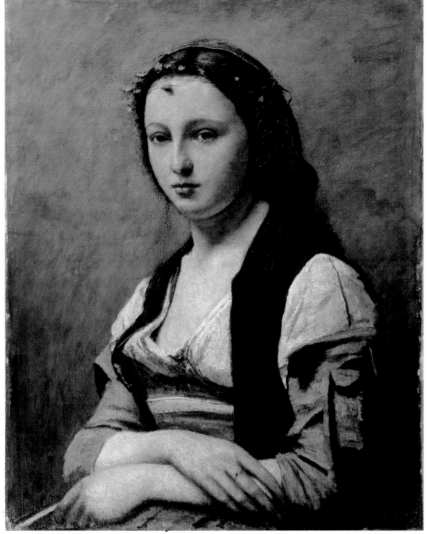

Camille Corot (1796-1875)

Woman with the Pearl

Painted in 1868 in the same pose as Leonardo's Mona Lisa, this splendid figure of a woman is something of a prototype among the portraits by Corot: the line is sure and confident, the figure is immersed in a calm light and there is a sense of peace and serenity, features which are typical of all the works by the great French painter, both his portraits and landscapes. It has been said of his art that he had the same way of looking at both men and nature, and indeed Corot approaches humanity and the material world with the same sincere feeling of respect and liking.

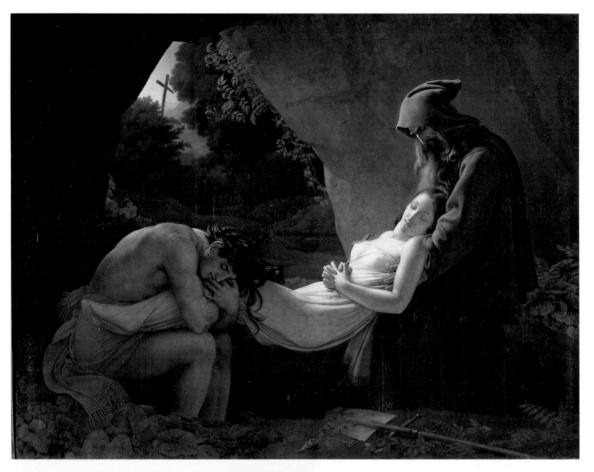

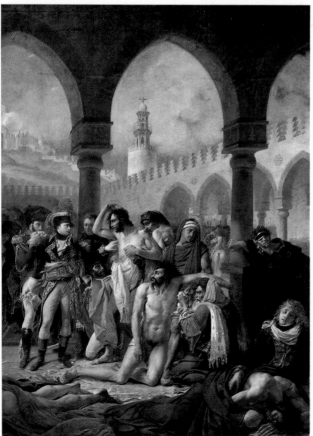

Anne-Louis Girodet (1767-1824)

The Entombment of Atala

The numerous disciples David, a celebrity and absolute master of the artistic scene, trained in his crowded Paris atelier assimilated his principles freely and to varying degrees.
One of these was Louis Girodet, who displayed a preference for pale lunar atmospheres and an accentuated chiaroscuro which models the figures which always emanate an ethereal and spiritual beauty.

Jean-Antoine Gros (1771-1835)

Napoleon Visiting the Plague-stricken at Jaffa *(detail)*

In the art circles which arose and revolved around David, Gros succeeded in conquering a place all his own thanks to his unique idiom and expressive power.
Having met with Napoleon's favour, he began to paint a series of large works meant to celebrate the battles, episodes, victories of the Emperor. Thus, as a faithful and impassioned reporter, he painted this enormous picture (more than seven meters long and over five meters high) to exalt Napoleon's courage during the Syrian campaign. The emperor is at the

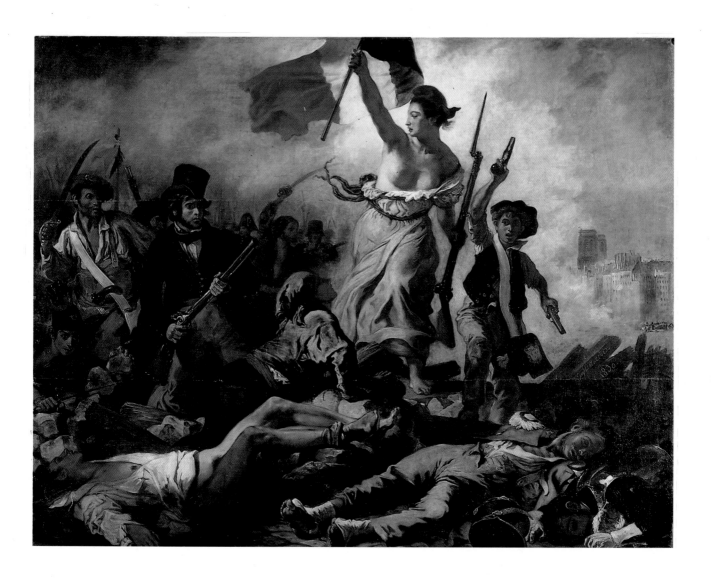

center of the composition: the participants in this dramatic episode of March 11, 1799 are scenographically grouped around him, in a rich range of colours.

Eugène Delacroix (1798-1863)

Liberty leading the People

This painting, which is a sort of political poster, is meant to celebrate the day of 28 July 1830, when the people rose and dethroned the Bourbon king. Alexandre Dumas tell us that Delacroix's participation in the rebellious movements of July was mainly of a sentimental nature. Despite this, the painter, who had been a member of the National Guard, took pleasure in portraying himself in the figure on the left wearing the tophat. Although the painting is filled with rhetoric, Delacroix's spirit is fully involved in its execution: in the outstretched figure of Liberty, in the bold attitudes of the people following her, contrasted with the lifeless figures of the dead heaped up in the foreground, in the heroic poses of the people fighting for liberty, there is without doubt a sense of full participation on the part of the artist, which led Argan to define this canvas as the first political work of modern painting.

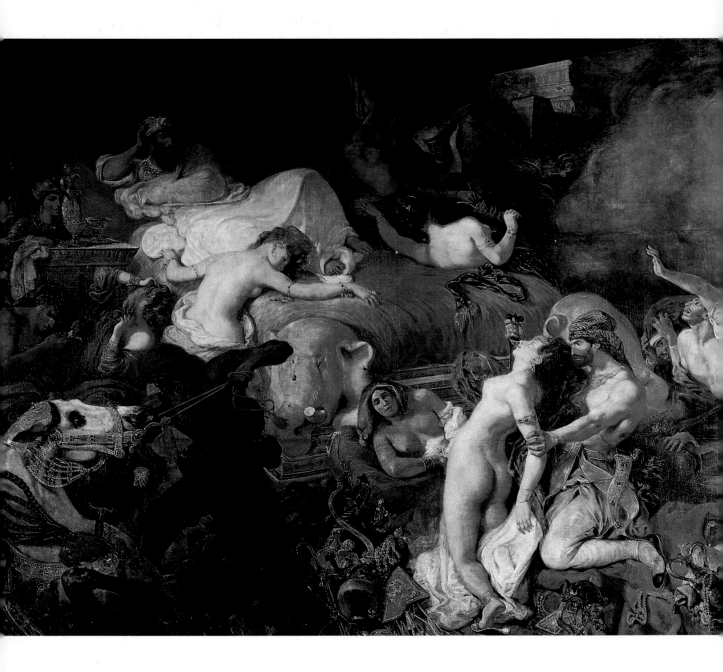

Death of Sardanapalos

Exhibited in the Salon in 1827-1828, this canvas was little appreciated because of its errors in perspective and above all because of the confusion which reigns in the foreground. The catalogue of the Salon describes it thus: «...the insurgents besiege him in his palace... Reclining on a splendid bed, at the top of a huge pyre, Sardanapalos orders the eunuchs and servants of the royal palace to butcher the women and pages and even his favourite horses and dogs... Aisheh, the Bactrian woman, because she cannot endure to be put to death by a slave, hangs herself from the columns which support the vault...». But Delacroix was not seeking order and precision of detail: his intention was to upset, dis-turb and exalt the mind of the viewer. The fascination of the Orient, the artist's long stay in Spain and Morocco and his celebration of the exotic and the mysterious have all left their mark on this canvas, as for example in the brilliant colours and in the gleam of the gold which blends with the red of the fabrics. Standing out above all is the sovereign, with his closed, indifferent expression, as he watches, unmoved by the massacre.

Scenes of the Massacres of Scio

An episode in the Greek war of independence, the Turkish massacre of 20,000 inhabitants on the island of Chio, touched the romantic nature of the young Delacroix, who exhibited this large canvas at

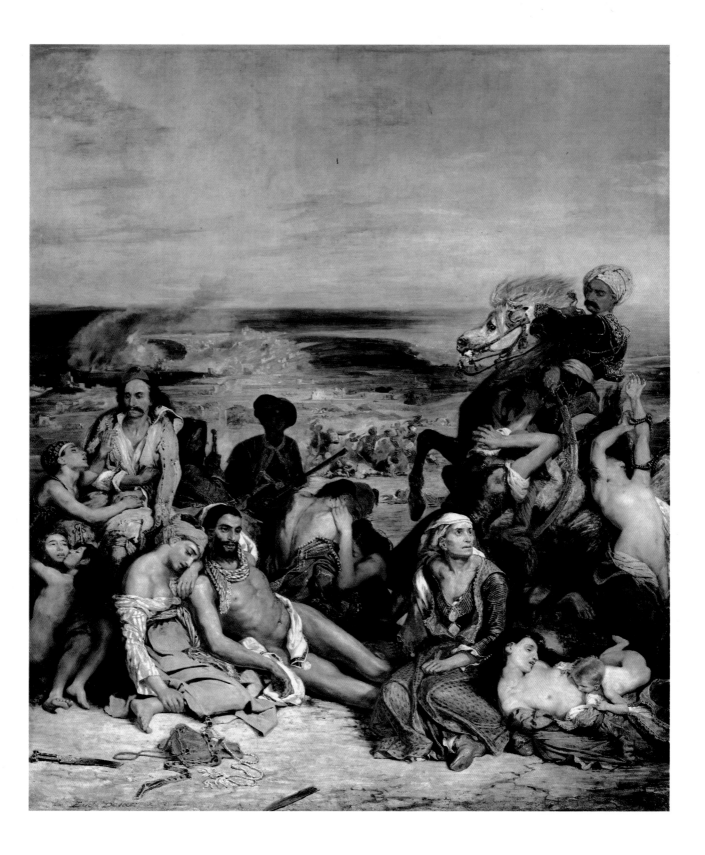

the Salon of 1824. The painting, however, was not well received, and while Baudelaire presented it as a hymn to human suffering, it is said that Gros defined it as a «massacre of painting».

The tragic episode is narrated with unusual figurative passion, the drawing seems to be free from preconceived patterns, and the development of the composition is more dynamic.

An infinite sorrow resounds from the grieving figures in the foreground to the background where the column of smoke from the burning houses tells us of still more death and violence.

ITALIAN PAINTING

THE «PRIMITIVES» AND THE EARLY RENAISSANCE

The revolution that had been launched in the various fields of thought and art is characterized by the return of the lessons of Antiquity, a return to Greek and Roman models. It gathered impetus in the fourteenth century, and took definitive shape in the second half of the fifteenth century.

Cimabue's solemn **Maestà** *(1270) announced an initial reaction against the hieratic Byzantine models. The artist replaced the formal linearity of Bizantium with a delicate modulation of volumes, freed the figures from their static poses, heralding the large altarpieces of Duccio and Giotto.*

During the fifteenth century, under the twofold influence of architecture (Brunelleschi) and sculpture (Donatello, Ghiberti), Italian painting moved towards the Renaissance. The artists of the Florentine school, the most famous at the time, distinguished themselves above all in their feeling for three-dimensional form and their passion for experimentation, particularly in the field of linear perspective, a crucial innovation which was to determine the pictorial idiom for various centuries. The dominant features of this school were determined by three painters: Masaccio established in its entirety the three-dimensional humanist ideal of the Renaissance, Paolo Uccello gave his **Battle of San Romano** *the monumentality of a high relief by means of his daring foreshortenings and the decorative stylization of form, emphasized by the cool colors; Fra Angelico integrated the lingering medieval universe of his* **Coronation of the Virgin** *with new discoveries in form and movement: breadth and balance of the structure, respect for perspective.*

In the middle of the century these studies led to the perfect mastery of volume and perspective, the greatest representatives of which were Piero della Francesca, Andrea Mantegna (see his **Saint Sebastian***), Antonello da Messina (see «***Il Condottiere***») and Giovanni Bellini.*

The Classicist centuries had paid no heed to these painters who were not represented in the royal collections. Merit for the first acquisitions for the Louvre go to Vivant Denon, Director of Museums under Napoleon. But the Primitives did not became fashionable in France until Napoleon III acquired the Campana collection, which brought around a hundred pictures to the Louvre, with the rest in what is now the Museum of the Petit Palais in Avignon.

THE HIGH RENAISSANCE

At the beginning of the sixteenth century, the Rome of the popes once more became the artistic capital, a role it had lost with the decline of Antiquity. All the projects and achievements of Bramante, Miche-langelo, Raphael were centered around the monumental undertaking of St. Peter's. This century also witnessed the birth of the Venetian school with its triumphant stress on colour, of which Giorgione was the guiding spirit with his disciple, Titian, its most illustrious representative.

*The section dedicated to the works of these artists contitutes one of the Louvre's most irreplaceable treasures, first and foremost for its unique collection of works by Leonardo da Vinci. Invited by François I, Leonardo came to stay in the chateau of Clos Luce near Amboise in 1516. On his death, François I acquired various of the great painter's works (in particular «***La Gioconda***» and the* **Virgin of the Rocks***) around which other masterpieces of the Italian Renaissance were gathered (Raphael's* **The Holy Family** *and* **La Belle Jardinière, Charity** *by Andrea del Sarto, etc.).*

This first fund, kept for a long time in the chateau of Fontainebleau, eventually was greatly enriched when Louis XIV acquired a part of the gallery of Cardinal Mazarino (1661) and that of the banker Jabach (1662-1671). Works such as Raphael's **Portrait of Baldassarre Castiglione***, Titian's* **Concert Champêtre** *and the* **Woman at the Looking Glass***, the painting by Correggio known as* **The Sleep of Antiope** *made their way into the Louvre. The Renaissance in its essence was thus already there when the Louvre was first created in 1793. Of the immense number of paintings requisitioned in Italy during the Revolution and the empire, only a few remained in the museum, such as the* **Wedding of Cana** *by Veronese, of outstanding importance.*

THE SEVENTEENTH AND EIGHTEENTH CENTURY

At the end of the sixteenth century a new chapter in painting began in Italy. Caravaggio, with his esthetics and his technique, exercised a profound influence on European art. The **Death of the Virgin***, bought by Louis XIV, at the time created a scandal as a result of its realism and the excessively accentuated dramatization of the contrasts of light and dark.*

Subsequently, numerous paintings of the school of Bologna (the Carraccis, Reni, Guercino, Domenichino), purchased or donated to Louix XIV by Italian art lovers, came to enrich the royal cabinet.

In the eighteenth century, Italian painting had its last moment of splendour in Venice. Unfortunately this period is represented in the Louvre in a fragmentary manner, despite an important group of canvases by Pannini, purchased under Louis Philippe, and the entrance, with the confiscations of the Revolution, of the admirable series of **Venetian Fêtes** *by Francesco Guardi. After the last war, the collection continued to grow and by now includes works by Canaletto, Tiepolo, Piazzetta, Pietro Longhi and Crespi.*

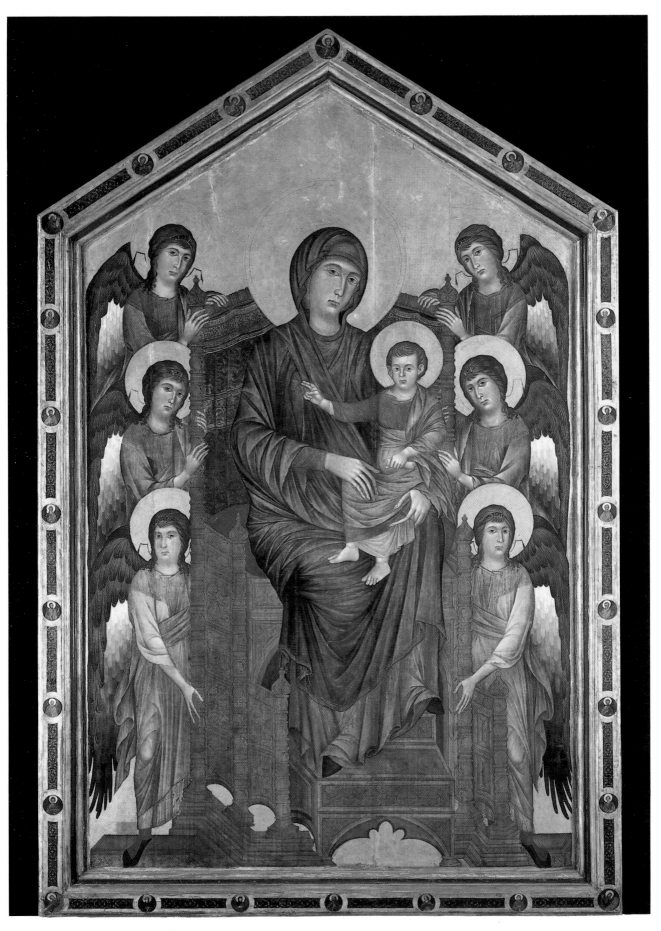

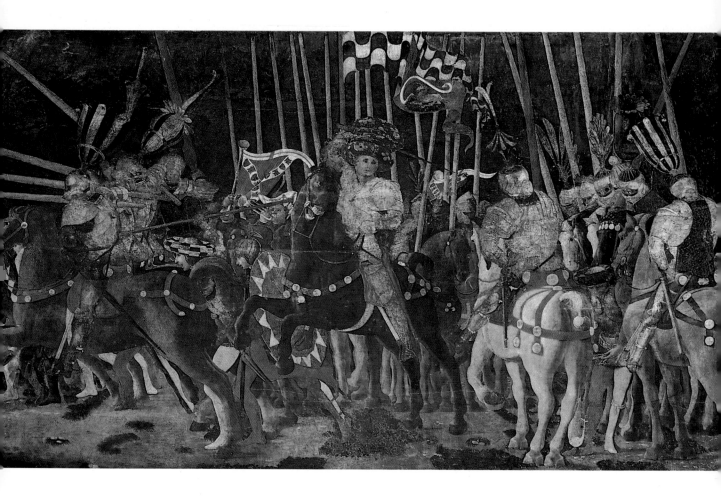

Cimabue (towards 1240 - after 1302)

The Madonna and Child in Majesty
(on the preceding page)

Probably painted for the church of San Francesco in Pisa, where it was prior to it removal to the Louvre in 1813, this **Maestà** reveals Cimabue's ties to Nicola Pisano's monumental sculpture even before 1272.
The fundamental characteristic of Cimabue's art clearly emerges from this panel: a precise incisive line and a powerful chiaroscuro which go hand in hand in creating a strong three-dimensionality.

Paolo Uccello (1397-1475)

The Battle of San Romano

Paolo Uccello painted three panels (now divided between the Louvre, the National Gallery in London and the Uffizi in Florence) depicting the three crucial moments in the battle which took place in June 1432 at San Romano between the Florentines, under the command of Niccolò Mauruzi da Tolentino, and the Sienese, led by Bernardino della Ciarda. In this panel in the Louvre, Uccello painted one of the decisive developments in the battle, the intervention of Micheletto da Cotignola on the side of the Florentines. The military captain is shown in the centre of the whole composition, as the horses paw the ground waiting for the attack. The lances of the soldiers stand out above the geometric suits of armour and elaborate helmets and crests. The panel (this is the best preserved of the three, in that it still retains the silver-plating on the armour) was painted along with the other two between 1451 and 1457 for the Medici Palace.

Pisanello (c. 1380-1455)

Portrait of a Noblewoman of the Este family

There are many theories about the identity of the woman portrayed in this panel, painted in tempera by Pisanello. The amphora embroidered on her sleeve seems to indicate that she is a noblewoman of the Este family, possibly Ginevra, the wife of Sigismondo Malatesta, whereas the sprig of juniper on her corset and the red, white and green colours would identify her as a Gonzaga, Margherita, wife of Lionello d'Este. In any case, whatever is the name of this young woman, whose profile stands out against the bush as if it were engraved, it is certain that the painting belongs to the artist's period of full maturity, that it was done towards 1436 or 1438.

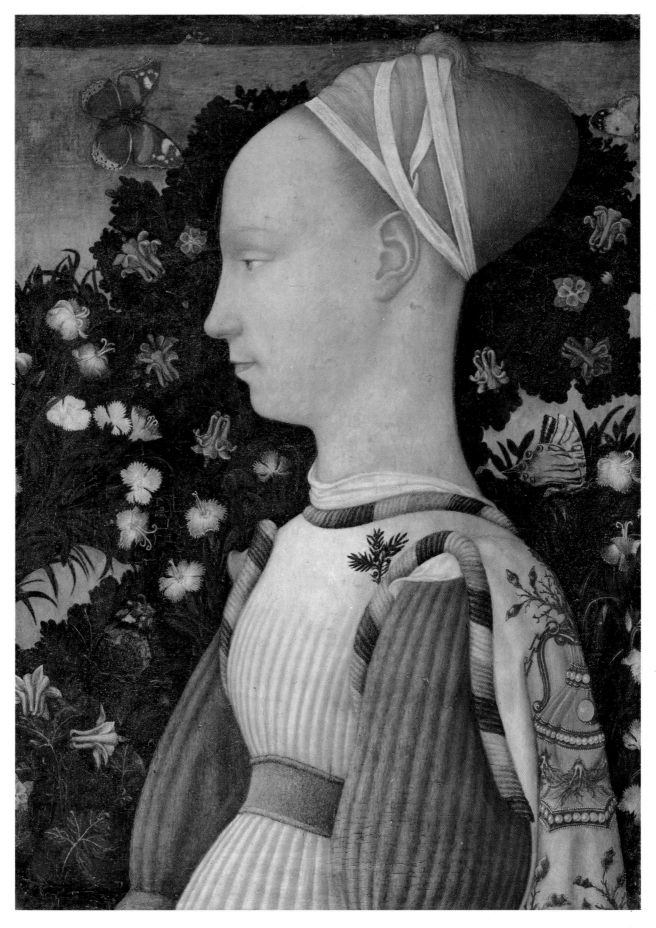

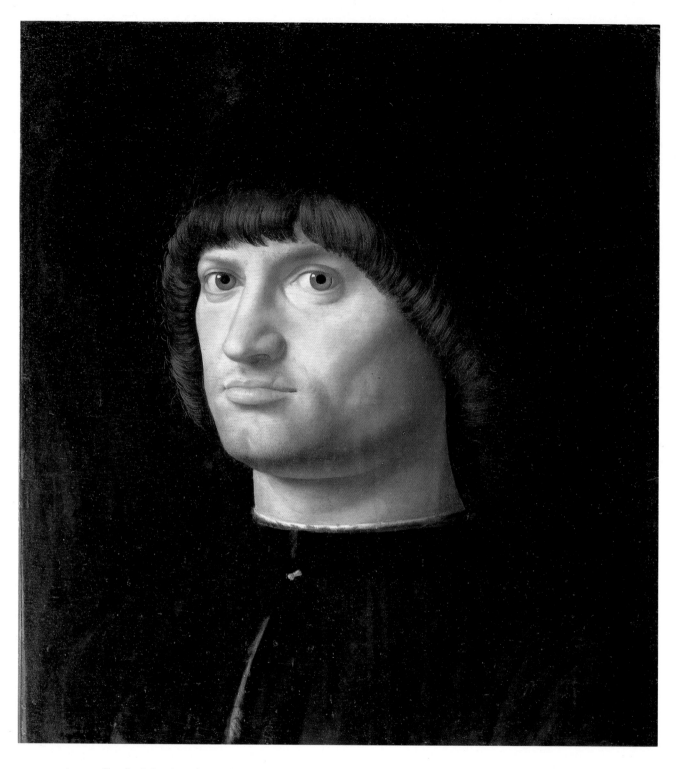

Antonello da Messina (ca. 1430-1479)

The Condottiere

This portrait of a man, property of the Louvre collections since 1865, takes its title from the resolute, bold expression that animates the canvas. The work is generally dated 1475, the year in which Antonello reached Venice and inaugurated a pictorial tradition which was destined to have a long life in that city.

Andrea Mantegna (1431-1506)

Saint Sebastian

In 1481, this canvas was brought to a small city in central France, Aigueperse, where it remained until 1910. Mantegna composed this monumental work making use of massive forms: it demonstrates that he fully understood the spirit of Roman architecture and the Florentine perspective vision. The saint's heroic acceptance of martyrdom redeems the coldness of the composition.

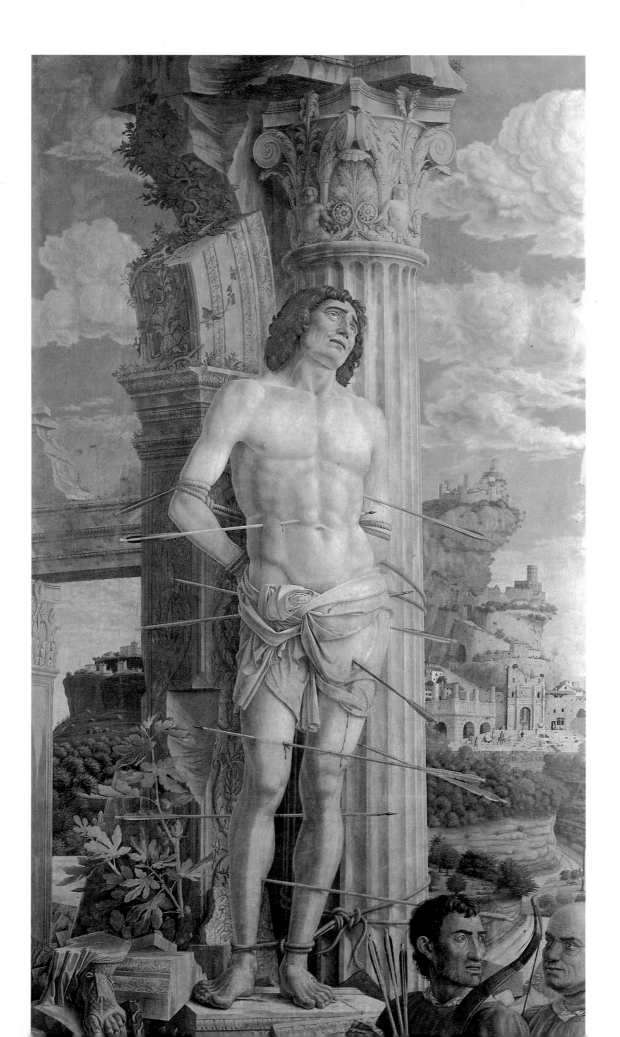

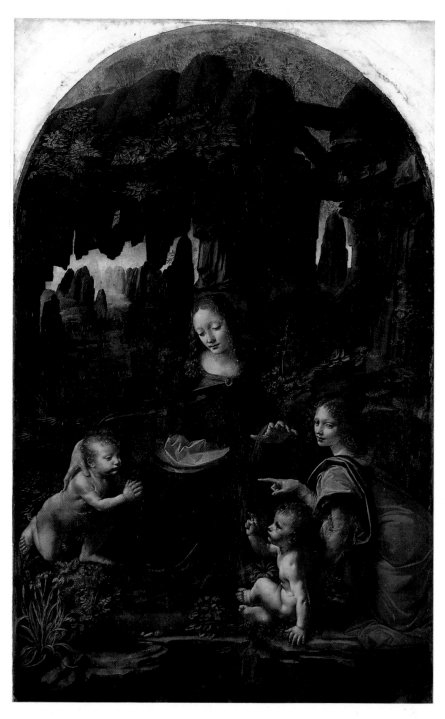

the rocks until it illuminates the group in the foreground, with its rigorously pyramidal structure.

Mona Lisa (The Gioconda)

Reams have been written about this small masterpiece by Leonardo, and the gentle woman who is its subject has been adapted in turn as an aesthetic, philosophical and advertising symbol, entering eventually into the irreverent parodies of the Dada and Surrealist artists. The history of the panel has been much discussed, although it remains in part uncertain. According to Vasari, the subject is a young Florentine woman, Monna (or Mona) Lisa, who in 1495 married the well-known figure, Francesco del Giocondo, and thus came to be known as «La Gioconda». The work should probably be dated during Leonardo's second Florentine period, that is between 1503 and 1505. Leonardo himself loved the portrait, so much so that he always carried it with him until eventually in France it was sold to Francis I, either by Leonardo or by Melzi. From the beginning it was greatly admired and much copied, and it came to be considered the prototype of the Renaissance portrait. It became even more famous in 1911, when it was stolen from the Salon Carré in the Louvre, being rediscovered in a hotel in Florence two years later. It is difficult to discuss such a work briefly because of the complex stylistic motifs which are part of it. In the essay «On the perfect beauty of a woman», by the 16th-century writer Firenzuola, we learn that the slight opening of the lips at the corners of the mouth was considered in that period a sign of elegance. Thus Mona Lisa has that slight smile which enters into the gentle, delicate atmosphere pervading the whole painting. To achieve this effect, Léonardo uses the *sfumato* technique, a gradual dissolving of the forms themselves, continuous interaction between light and shade and an uncertain sense of the time of day.

Leonardo da Vinci (1452-1519)

The Virgin of the Rocks

Begun, according to some critics, in Florence in 1483 but not completed until about 1490, this magnificent work corresponds to another version (most of which was painted by Ambrogio de Predis), now in the National Gallery in London. Leonardo may have received the commission for the work from the Confraternity of San Francesco Grande in Milan; certainly, at any rate, the painting was at Fontainebleau in 1625, and this may permit us to deduce that it was part of the group of works by Leonardo acquired by Francis I. The light in this painting comes from the background, filtering laboriously through the fissures and clefts of

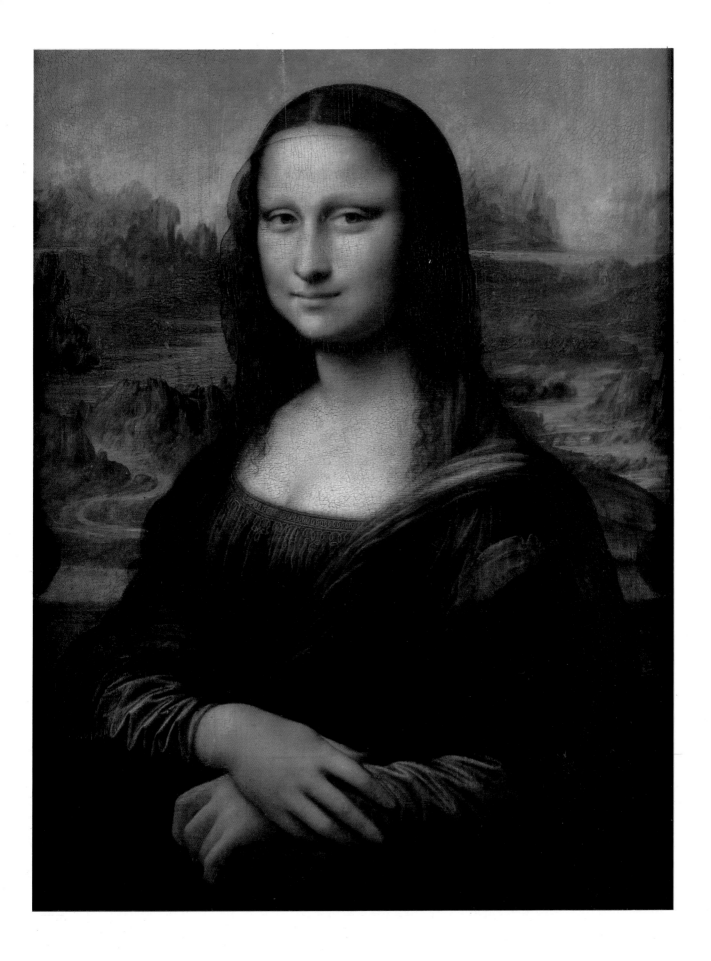

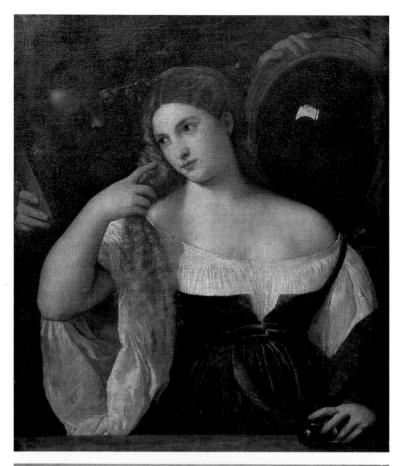

Woman at the Mirror

This canvas by Titian is usually dated at 1515, that is in the period when the great Venetian painter was still to a large extent under the influence of Giorgione. In fact the warm golden nudity of the woman, the ample white corset opening in numerous folds on her breast and the mass of loose hair are typical of Giorgione. Some critics say that the woman portrayed here is Laura Dianti, the mistress of Alfonso d'Este, while others say that it is Titian's own mistress, but in any case she recurs in many other paintings by Titian.

Raphael (1483-1520)

Portrait of Baldassarre Castiglione

This canvas, dating from 1514-1515, portrays Baldassarre Castiglione, a friend of Raphael and the author of the celebrated «Cortegiano» (The Courtier). Raphael gives us a splendid interpretation of his subject, not only psychological but above all historical, portraying him with a noble, aristocratic expression. The work displays perfect harmony between linear and tonal values: the subject's form is tranquilly contained within the space created and the sober colours reach a perfect equilibrium of grey and gold tones. The pose, a three-quarter bust with the hands linked in front of the body and the figure majestically dressed in velvet and fur, recalls the pose in the portrait of Ginevra Benci and of the Mona Lisa. After leaving Italy, this canvas reached Amsterdam where it was sold at auction in 1639. It became part of the collection of Cardinal Mazzarino, and later entered the collection of Louis XIV.

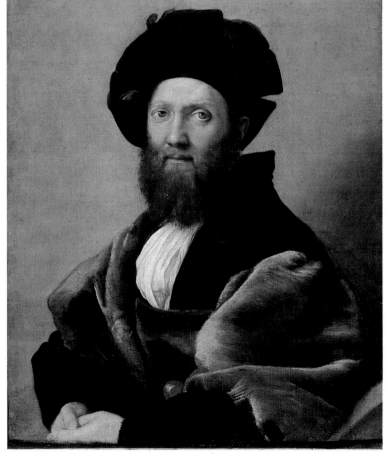

Madonna and Child with the Infant St. John (La Belle Jardinière)

Painted in 1507, this work belongs to Raphael's Florentine period, between 1504 and 1508. It is signed «Raphaello Vrb» on the hem of the mantle and dated MDVII near the elbow. The serene and tranquil beauty of the Virgin, the meadow full of plants and flowers, are why the painting came to be known as «La Belle Jardinière».

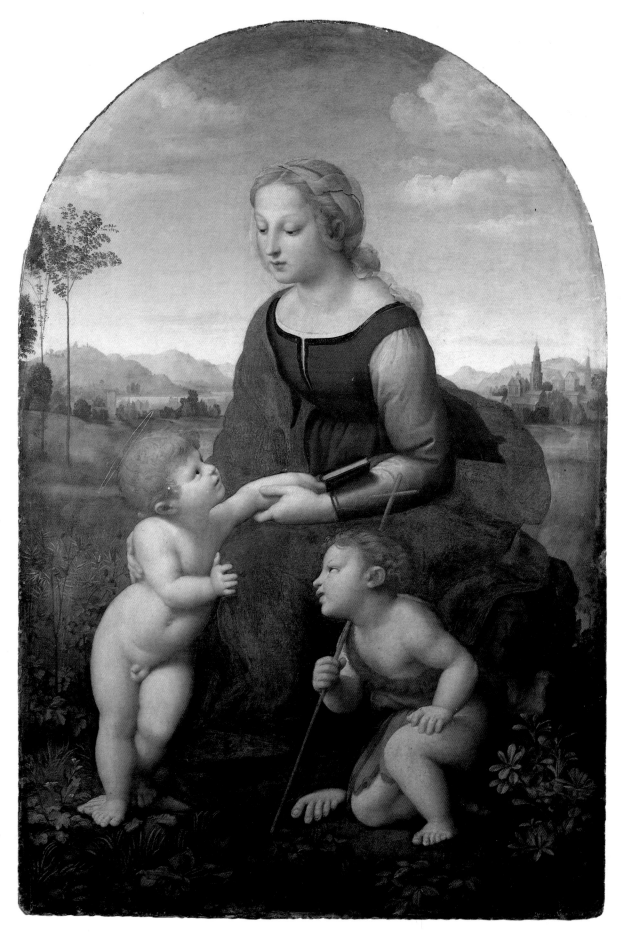

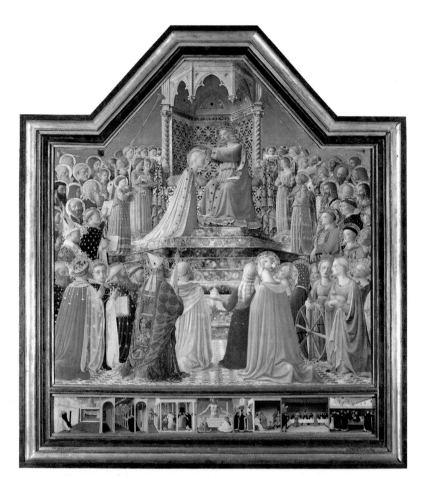

Fra Angelico (1387-1455)

The Coronation of the Virgin

The central panel depicts the *Coronation of the Virgin*; the predella – which was still in the hands of a Florentine antique dealer in 1830 – contains scenes from the life of Saint Domenic. The bright colours, the three-dimensionality of the figures, the perspective lines in the pavement which call to mind Domenico Veneziano, all make this altarpiece one of Angelico's most famous paintings.

Paolo Veronese (1528-1588)

The Marriage at Cana

Among the various Suppers which Paolo Veronese painted, this one in the Louvre is one of the finest. In this work, as in the others, the religious episode is no more than a pretext to describe a magnificent ceremonial occasion in the highly fashionable Venetian society of the 16th century. Within typically Palladian architectural surroundings, Veronese paints a crowd of more than 130 figures.

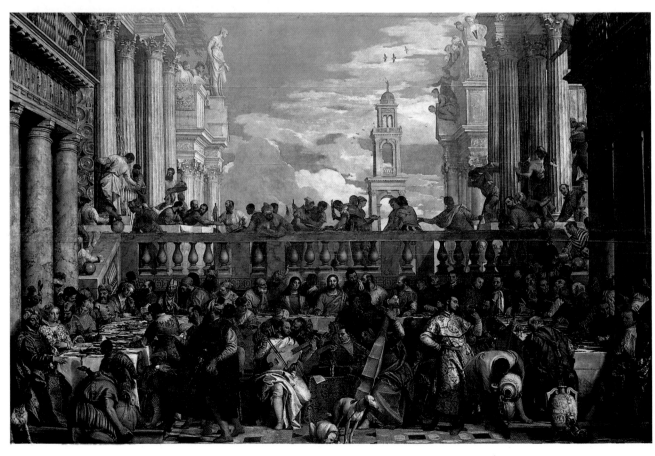

Caravaggio (1571-1610)

The Fortune Teller; The Death of the Virgin

Caravaggio's personality is truly unique: «a cursed painter, rebellious and unconventional, genius and intemperance fused giving rise to one of the most controversial and unique artistic expressions».

Caravaggio never held classic beauty in high esteem, preferring to represent reality with a brutal sincerity that verged on unconventionality. Light is never suffered: violent and dramatic, it reveals a down to earth and sanguine reality. The figures are poorly dressed common folk, with calloused hands and wrinkled faces, feet are often in the foreground and are dirty. This «naturalism» of Caravaggio's not only antagonized his patrons but was defined as unseemly and offensive.

As in the painting of **The Fortune Teller,** painted around 1590/93 where, as Giulio Mancini tells us; Caravaggio «*...called a gypsy who was passing by chance in the street and portrayed her as she was predicting the future...*».

This was even more evident in the **Death of the Virgin,** painted in Rome in 1606 for the Barefooted Carmelites of the Church of Santa Maria della Scala and refused by them because they believed that the figure of Mary, prostrate on her death bed, was that of a prostitute who had drowned in the Tiber and whom Caravaggio had used as a model.

ART OBJECTS

When the main Museum was opened, the section dedicated to the minor arts was essentially the result of two acquisitions. In 1793 it was decided to transfer to the Louvre part of the treasure of the abbey of Saint-Denis, including the sacred **regalia** of the kings of France and the precious vases the abbot Suger had collected in the twelfth century which are now on exhibition inside the Galerie d'Apollon (see the **Scepter of Charles V**). In 1796 the collections in the Louvre were completed by the vases in pietra dura and the bronzes collected by Louis XIV and kept, ever since 1774, in the storerooms for the custody of the furnishings of the Crown, in what is now the Ministry of the Navy. This original fund was enriched in the course of the nineteenth century by prestigious acquisitions and donations: the acquisition of the collections d'Edme-Antoine Durand (1825) and of the painter Pierre Révoil (1828) considerably enlarged the section devoted to objects from the Middle Ages and the Renaissance (stained glass, enamels, ivories, tapestries and furniture); the Charles Sauvageot donation in 1856 on the other hand includes one of the largest collections of ceramics of the school of Palissy; lastly, the acquisition, in 1861, of the Campana collection by Napoleon III made the Louvre one of the most important museums in the world for its collection of Italian majolica.

Thanks to these rich acquisitions, in 1893 a section was constituted within the Louvre that was dedicated to Objects from the Middle Ages, from the Renaissance and from Modern times, distinguished from those in the departments of Antiquity and Sculpture. From then on the collection never stopped growing, thanks to new and important donations such as those of Baron Adolphe de Rothschild (1901) and the wife of Baron Salomon de Rothschild (1922).

The section dedicated to furniture, tapestries and bronzes of the seventeenth and eighteenth centuries owes its origins to the assignments of 1870 and 1901 by the storerooms for the safeguarding of the furnishings of the Crown (later Mobilier National) consisting of deposits from precedent royal residences (above all those of Saint-Cloud and the Tuileries), to which were added the donations of Isaac de Camondo (1911), Baron Basile de Schlichting (1914) and René Crag-Carven (1973).

In 1993 the installation will be greatly changed: the collections of objects from the early Middle Ages to the seventeenth century, currently to be found in the de la Colonnade wing, will be redistributed inside the rooms on the first floor of the new Richelieu wing. The circuit will then continue in the North wing of the Cour Carrée with the rooms dedicated to the eighteenth century. Only the jewels and precious gems will continue to be shown in the Galierie d'Apollon.

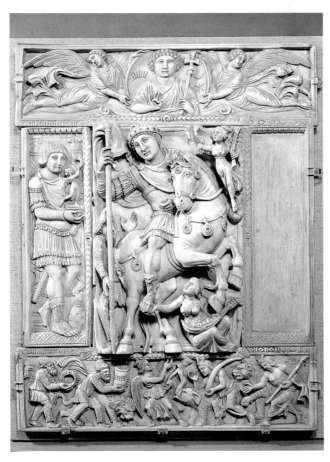

«Barberini Diptych» -
Ivory from Constantinople (late 5th-early 6th century).

French art of the second half of the 14th century -
Scepter of Charles V, with Charlemagne at the top and
three scenes from the legend of Charlemagne in low
relief at the juncture.

French art of the 14th century -
Virgin of Jeanne d'Evreux in gilded silver, enamel,
pearls and semiprecious stones.

◄ Coronation of the Virgin -
polychrome ivory (late 13th century).

FLEMISH AND DUTCH PAINTING

THE PRIMITIVES

The painting of the Nordic school is the result of a synthesis between the precise linear expression of the miniaturists, the subtle range of colours of the Italians and Gothic naturalism. All these features are already present in the works of the Van Eyck brothers, in particular in **The Virgin and the Chancellor Rolin** *(circa 1435) where a realism that was to become one of the specific characteristics of this school is affirmed. Subsequently various painters such as Rogier van der Weyden (see* **Annunciation***) or Memling (see* **Portrait of an Old Woman***) will dilute this realism with a melodic linearity that recalls the Gothic. Various features of this style were to be continued beyond the limits of this century by two great masters: Hieronymus Bosch (see* **The Ship of Fools***) and Bruegel the Elder (see* **The Cripples***).*
It is highly probable that the collection of François I also included various contemporary Flemish paintings. Even so not until the creation of the Musèe Napoleon did the Flemish primitives become famous. Among the numerous works requisitioned, only those of Van Eyck and Roger van der Weyden, as well as **The Banker and his Wife** *by Quentin Metsys, bought in Paris in 1806, remained in the Louvre.*

THE SEVENTEENTH CENTURY

From the sixteenth century on, the political and religious rupture between the northern and southern provinces of the Low Countries played a part in the divergence that took place between the Flemish and Dutch schools. Once it had become independent, Holland developed an art all its own, imbued with the severe and somber atmosphere of the reformed church and favoured by a new wealthy bourgeois class. Rembrandt and Frans Hals portrayed the assemblies of the great confraternities of their times with a keen psychological intensity. Flemish painting, on the other hand, was dominated by the genius of Rubens. The first paintings to enter the royal collections in the seventeenth century were those by living artists who had come to Paris to work for the queen, Marie de Médicis: Frans Poubrus, who painted the official portrait of the queen, and Rubens, called to execute the decoration of the gallery in her palace in Luxembourg (see **The Disembarkation of Marie de Médicis in Marseilles***). Masterpiece of Baroque painting, this work however was not to influence French Classicism until the end of the century, a period in which those who championed «colour» prevailed over the Poussinists, who argued the primacy of drawing. The collections of Flemish painting multiplied and the king's cabinet was enriched by new works by Rubens (***Kermesse***) and Van Dyck, not to mention the great Dutch masters (in particular the* **Portrait of the Artist at his Easel** *by Rembrandt).*
*With Louis XVI, and more precisely, with his Director of Constructions, Conte d'Angiviller, the collection was substantially enlarged. Imbued with the encyclopedic spirit of his contemporaries, d'Angiviller did all he could to fill the lacunae in the museum, above all as far as the Northern schools were concerned. Other paintings by Rubens (***Helene Fourment***) Van Dyck (***Charles I, King of England***) and Rembrandt (***Supper in Emmaus***), as well as works by Jordaens, Ruisdael and Cuyp, were purchased.*
This fund was further enriched by various masterpieces which Doctor La Caze donated during the Second Empire, in particular the **Bohemienne** *by Frans Hals and* **Bathsheba** *by Rembrandt.*

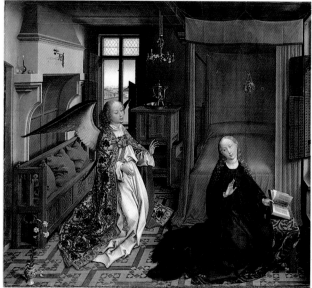

Jan van Eyck (1390-1441)

The Virgin and the Chancellor Rolin

Preserved in the Collegiate Church of Autun until the period of the Revolution, this wooden panel was painted between 1434 and 1435.

In this picture van Eyck, father of fifteenth-century Flemish painting, has bequeathed us with one of the loftiest works in the history of painting. The calm and solemn figures are set against a glowing landscape. The mute dialogue between the chancellor and the Virgin is eloquent and moving, absolutely devoid of mystical transports.

Rogier van der Weyden (1399-1454)

The Annunciation

Van der Weyden once more presents us with an example of the Flemish concept of space in this painting which is considered among the earliest of his certain works.

A room, small in size but with a wealth of details, an open window hinting at a countryside crossed by a river, a highly natural atmosphere all make it seem as if we had entered a bourgeois house and momentarily interrupted an intimate conversation.

Hieronymus Bosch (c. 1450-1516)

The Ship of Fools

«The Ship of Fools» by Sebastian Brandt was published in Basle in 1494. This book was to have a widespread diffusion and was to inspire Bosch, one of the most original personalities of Dutch painting, who stigmatized the corruption of the clergy and society of his time in this wooden panel. Ferocious anticlerical satire is evident in his depiction of the friar and the nun who attempt to bite into the loaf which swings from the tree-mast of the small boat and the owl which peers out from between the foliage alluding to the presence of heresy.

Hans Memling (c. 1433-1494)

Portrait of an Old Woman

This small painting on panel was originally a companion piece to the Portrait of an Old Man (now in the Staatliche Museen in Berlin), and in fact they were sold at auction together by the collector Meazza in Milan on 15 April 1884. Later they were separated and this Portrait of an Old Woman passed through the hands of various private collectors until it was finally acquired by the Louvre in 1908. Apparently painted towards 1470 or 1475, it shows the woman in a half-bust figure, closed geometrically in her dress and placed in front of a landscape according to the Flemish tradition, followed previously by van der Weyden.

Quentin Metsys (1465-1530)

The Banker and his Wife

This panel has the inscription «Quinten matsyss schilder, 1514»: it is thus a signed work by Quenten Metsys, an important Flemish artist who belonged to the transition between the Middle Ages and the Renaissance and who painted altarpieces as well as non-religious subjects. In Metsys' work, genre painting assumed an importance which until then only works of a religious nature had had. The artist's moralistic or satirical intentions are evident, in this panel as elsewhere in his work. Here he has carefully described the surroundings in the most minute detail and painted the banker as he is weighing coins on a scale. His wife, who has been occupied up until now reading a sacred book, looks up, visibly attracted by the glitter of the gold. The illuminated page of the book thus remains open, while a round mirror (reflecting a window and the landscape outside) stand as a symbol of vanity.

Peter Paul Rubens (1577-1640)

La Kermesse

Perhaps no other artist succeeded so brilliantly as
Rubens in combining the colour technique of the
Venetians with the Flemish tradition. With him the
Baroque school had its greatest triumph: a triumph
of colour, of the exaltation of life, an impetus of joy.
This higly animated composition belongs to the
final period of Rubens' activity, that is to about
1635 or 1638. The recollection of the Kermesses,
the dances in the fields, and the open-air feasts
painted by Breughel the Elder can certainly be felt:
like his predecessor, he liked to create a figure rotat-
ing in space and transmitting this movement to the
figures beside it and thence throughout the whole
group. The entire scene thus becomes a series of
whirling couples clutching each other, figures which
tend to lose their human identity.

Anthony van Dyck (1599-1641)

Portrait of Charles I

A pupil and helper of Rubens, Anthony van Dyck
came from the same background as his master but
broke away at an early stage to establish his own,
highly personal style. Summoned to England by
Charles I, he became the official painter of the royal
court and was also knighted. During his stay there
(which lasted from 1632 to 1641), he did many por-
traits of the monarch, but this work, painted in
about 1635, is the most celebrated and the finest of
them. Here Charles I is portrayed as a typical Eng-
lish gentleman after his return from the hunt. The
brilliant, almost shrill colours of Rubens are
attenuated into softer, more delicate tones: the
strong passions of his master have become in the
pupil a sort of absorbed psychological introspection.
The potraits of van Dyck established a tradition in
England which was to put down deep roots.

Peter Paul Rubens (1577-1640)

The Disembarkation of Marie de Médicis

The cycle dedicated to Marie de Médicis includes twenty-one canvases which Rubens painted between 1622 and 1625 to represent the most important events in the life of his royal patron. The painting shown here refers to the landing of the future queen of France in Marseilles on November 3, 1600, while Fame announces her arrival and Neptune with Tritons and Naiads pull in the boat of the Grand-duchess of Tuscany.

Rubens has frequently been criticized for having painted too many «fat women». Even though he fused history and ancient mythology in his painting, the artist no longer appreciated the ideal forms of classic beauty: his vision of the world led him to represent everything with joy, exuberance, and energy. His female nude is thus never abstract in her beauty, but is a glorious, sensual, baroque nude. In this sense Delacroix' definition of Rubens as the «Homer of painting» is eminently suitable.

Pieter Bruegel (1525/30-1569)

The Cripples

Various interpretations have been given to this small wooden panel (18×21 cm., the smallest of Bruegel's pictures), signed and dated 1568. There are six figures, but the faces of only two are clearly visible: the others are nothing but deformed bodies, solid volumes painted in strong contrasting colours. The fox tails hanging from the ragged clothing were once the mark of lepers, warning people to keep at a distance. The odd hats of Carnival type – a crown, a bishop's miter – may perhaps allude to the various social strata.

It is highly likely that Bruegel, who always used his painting as a means for denouncing society, intended this picture as a satire of humanity as a whole, divided, to be sure, into social castes, according to privileges and characteristics of class, but also tragically alike in their unhappiness and misery.

In this sense, despite its small dimensions, this painting by the great Flemish master has a monumentality that is truly heroic.

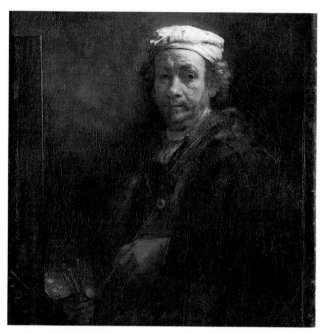

Rembrandt van Rijn (1606-1669)

Portrait of the Artist at his Easel

It was 1660 when Rembrandt painted this self-portrait: he was no longer young, the patrimony accumulated with his first wife Saskia had been lost, the precious objects in his collection had been auctioned off, his popularity was on the wane and he was ever deeper in debt. Faithful as always to his search for light, Rembrandt painted himself at his easel with absolute sincerity: the face of the man we see is tired but has not given in to the vicissitudes of life.

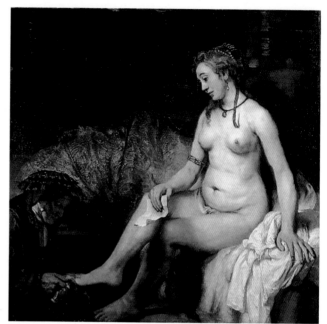

Bathsheba

In 1654, when Rembrandt painted this picture, the young Hendrickje Stoffels had already entered his life. She was to take care of Titus, his son by his first wife, and was to give the painter a daughter, Cornelia.
Here Rembrandt portrayed her as Bathsheba holding the letter in which David declares his love. The painting is imbued with a profound intimacy and great realism.

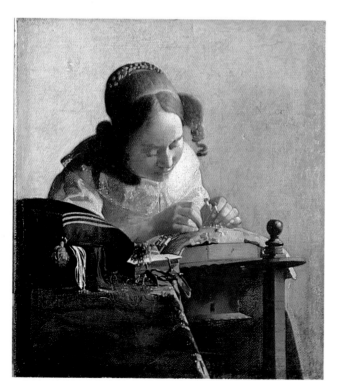

Johannes Vermeer (1632-1675)

The Lacemaker

The canvases of Vermeer, a painter forgotten for quite a long time, rediscovered only around 1850, carry us, as if by magic, into the intimate milieu of the bourgeoisie: a simple and never-changing life, made up of small, commonplace, everyday actions. But the perfect harmony among the lights, the volumes and the colours that reigns in Vermeer's compositions (of which this Lacemaker is one of the most well-known and most beautiful) transfigures the simple character of the theme, elevating it to the most exalted spheres of absolute values. The canvas is dated ca. 1664-1665: auctioned in Amsterdam in 1696, it was part of more than one private collection before making its way to the Louvre in 1870.

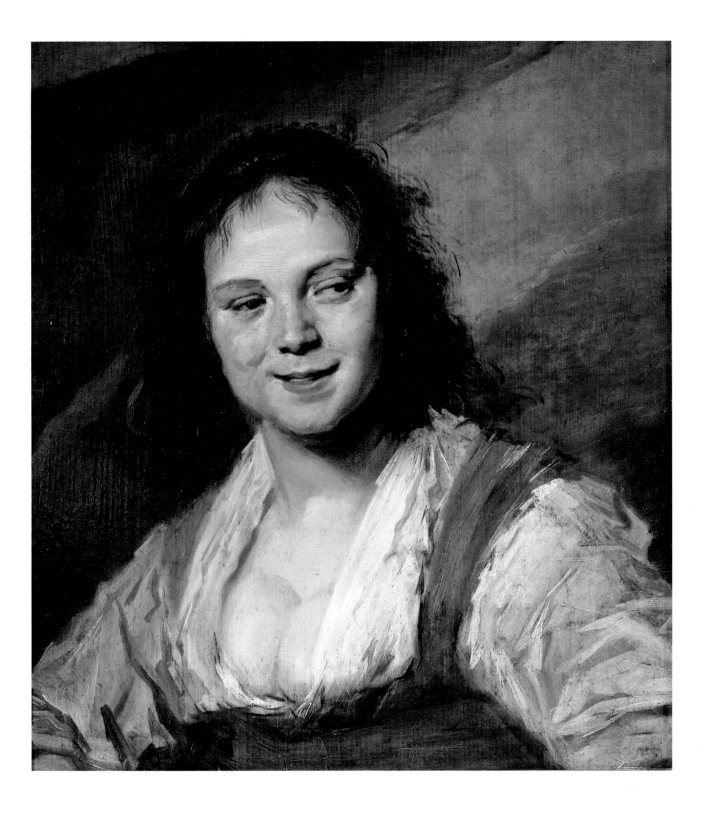

Frans Hals (1580-1666)

La Bohémienne

A Dutch painter, Hals had many contacts with the northern followers of Caravaggio, which led him to depict in his canvases members of the lower classes, drinkers in taverns, old drunken women. This portrait, usually dated between 1628 and 1630, represents a gypsy woman, dishevelled, smiling, with her corset open at the breast. Hals' brushstroke is extremely rapid and intense, revealing the psychology of the subject. It was part of the collection of de Marigny, brother of Madame la Pompadour, then passed into the Lacaze collection, from which it was left by will to the Louvre in 1869.

SPANISH PAINTING

The collection of Spanish painting in the Louvre is of recent date. Classicist Europe from the sixteenth to the eighteenth century ignored or misinterpreted this school: Ribera was the only one who achieved glory, but as a Neapolitan painter. Despite the fact that two successive queens came from Spain, Anne of Austria and Maria Theresa, only three artists – Velázquez, Collantes and Murillo – were represented in the royal collections. **The Burning Bush** by Collantes and the **Portrait of the Infanta Margarita** by Velázquez, a gift of Philip IV to his sister, queen Anne of Austria, were practically the only Spanish works to be found in Louis XIV's collection. Under the reign of Louix XVI a few pictures by Murillo, the first Spanish artist to be known and appreciated in France, were added. Included among these was **The Young Beggar**, one of his masterpieces, which was purchased from the dealer Lebrun.

With the advent of Romanticism everything changed and Spain became fashionable. During the Empire, collections which were the fruit of confiscation during the Napoleonic wars, such as those of Giuseppe Bonaparte and Marshal Soult, had a distinct advantage. Louis Philippe however can be credited with introducing the masterpieces of the Golden Century to the public at large: his collection, duly purchased in Spain by his emissary, Baron Taylor, and exhibited at the Louvre from 1838 to 1848, was to be a fertile source of study for young artists such as Courbet and Manet. Unfortunately this collection of more than four hundred works went with the sovereign into exile and was eventually sold at auction in London in 1853. The only painting the Louvre was later able to recuperate was the **Christ on the Cross** by El Greco, purchased in 1908.

While on the one hand this great loss is deplorable, on the other the quality of the acquisitions and donations in the second half of the nineteenth and in the twentieth century are highly laudable. During the Second Empire, the breaking up of the Soult collection permitted five masterpieces to enter the Louvre, including two scenes from the **Life of Saint Bonaventura** by Zurbaran. A few years later, the La Caze bequest brought in the famous **The Club-footed Boy** by Ribera. Lastly, at the beginning of the twentieth century, a series of prestigious acquisitions filled a few outstanding lacunae. The primitive masters were included in the selection (Mastorell, Huguet, the Master of San Ildefonso) and thus some of the important works by seventeenth-century masters missing from the fund (Valdés Leal, Alonso Cano, Espinosa) were appropriated.

Despite its limitations, the Spanish collection of the Louvre, at present numbering around fifty pictures, is sufficiently representative and provides a complete panorama of the various periods with divers outstanding works.

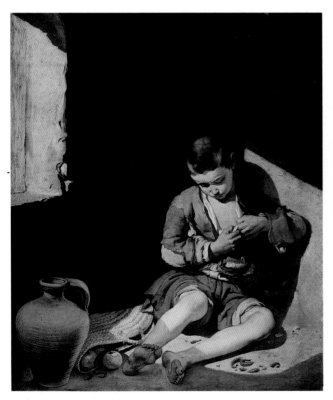

Esteban Murillo (1618-1682)

Young Beggar

Murillo, unlike other famous Spanish painters who were among his predecessors, kept his distance both from the luxuries of the court and from their gloomy and obsessive mysticism. His faith has a serene quality, untouched by anguish and doubt, while at the same time his scenes of the daily life of the common people are never dramatic or unpleasant. Even in conditions of poverty, in fact, Murillo seeks the most beautiful and delicate aspects, far from the dramatic effects created by the violent contrast between light and shade typical of Caravaggio. Thus this young beggar, despite the rags and tatters of his clothes, is a finely drawn, pathetic figure.

Diego Velasquez (1599-1660)

The Infanta Margarita

Velasquez painted many portraits of the Infanta Margarita, daughter of Philip IV and of Marianna of Austria. This canvas, done in about 1653, may have been one of the royal portraits which the king sent to his sister Anna, Queen of France. The painting belongs to the finest, most mature period of Velasquez' artistic activity at the court of Spain: his colour has reached its warmest tones, his chromatic relations are at their most exact, while the luminous quality which touches the face of the child is not at all aggressive, but combines smoothly and precisely with the golden yellow mass of her hair. In a job of restoration done in 1659, the words at the top of the painting, «LINFANTE MARGUERITE», which had been added later, were removed.

Francisco Goya (1746-1828)

The Countess of Carpio

At almost the same time in which the passionate, complex mind of Goya was creating the Caprices, the painter was still able to paint serene and delicate works like this portrait of «Dona Rita de Barrenechea, Marquesa de la Solana y Condesa del Carpio», done between 1794 and 1795. Goya's famous portraits, painted for members of the court circle, represent the other side of his art, a far more relaxed side which is not concerned with the anguish and disasters which war and the hypocrisy and evil of man bring about. Behind the Countess, Goya creates an empty space, which throws into relief the sumptuous black velvet of her long dress, the fine white lace of her mantilla and the large pink rose, realised with a few skilful touches of light.

GERMAN PAINTING

The importance of the collection of German painting in the Louvre is indisputable, even though the number of pictures included is relatively small.

The fifteenth century is dominated by a deservedly interesting group comprised of painting of the school of Cologne: the Master of the Holy Family and the St. Severin Master adhere to the style of Stephan Lochner, whose personality dominated the first half of the fifteenth century, while the influence of Flemish art can be noted in the works of artists such as the Master of St. Bartholomew (panel of the **Descent from the Cross**).

The star of the collection dates to the Renaissance. The origins of this section are particularly prestigious: the five portraits by Holbein, the glory of the museum, entered the royal collection in the seventeenth century. The **Portrait of Erasmus** was a gift of Charles I of England to his brother-in-law, Louis XIII. The other four paintings (in particular the portraits of **Nicholas Kratzer** and **Anne of Cleves**) were part of the collection of the banker Jabach which Louis XIV purchased in 1671. In these paintings Holbein gives proof of his talent as a portrait painter, combining a meticulous attention to reality with a surprising feeling for the simplification of volume and form.

Albrecht Dürer who, together with Holbein, was a classic example of the Humanist artist of the German Renaissance, is represented by his **Self-portrait** of 1493 which entered the Louvre in 1922.

The collection also includes sundry paintings by Lucas Cranach, in particular a **Venus** acquired in 1806.

Other names, in addition to these great three, bear witness to the wealth of art resources to be found in sixteenth-century Germany, but their presence in the Louvre is only fragmentary, with canvases by Hans Baldung Grien (**The Knight, the Maiden and Death**), Wolf Huber and Hans Sebald Beham.

Hans Holbein the Younger (1497-1543)

Erasmus of Rotterdam

The picture on exhibit in the Louvre, painted in 1523 during Holbein's stay in Basle, is perhaps the finest of the portraits of the great reformer. It is certainly the most famous, and has become the image *per antonomasia* of the humanist. Erasmus is shown absorbed in writing his *Commentary on the Gospels of St. Mark.*

Albrecht Dürer (1471-1528)

Self-portrait with a Ricinus Flower

In 1493 on a study trip in Basle and Strassburg, Dürer painted this self-portrait which he then probably sent to his fiancee, Agnes Frey, whom he was to marry on his return to Nuremberg.

The ricinus flower in the artist's right hand is thought to represent conjugal fedelity but it is also a symbol of the Christian faith, if we read the inscription at the top which says «My sach die gat als es oben schtat», which means «My things go as ordained on high».

Lucas Cranach the Elder (1472-1553)

Venus

After an initial period in which Cranach submitted to the seduction of the northern landscape, his style became more elegant and mannered as painter at the court of Saxony. Between 1525 and 1535 he painted numerous pictures of Venus, often accompanied by Eros, in which the grace and beauty of the woman is entrusted to the nervous restless outline.

SCULPTURE

In the history of the Musée du Louvre, the creation of a department dedicated to sculpture (Medieval, Renaissance and Modern) is of relatively recent date. When the museum opened its doors the only examples of sculpture were Michelangelo's **Prisons**, confiscated as the belongings of emigrants from the daughter of Maréchal de Richelieu. It was not until 1824 that the «Galerie d'Angoulême», the first section of sculpture, was opened by Comte de Forbin, at the time rector of the museums. A sculpture section worthy of the name, no longer subject to the department of antiquity or of the Decorative Arts, was not instituted until 1871.

The collection inherited numerous funds, which up to then had been scattered here and there and which were only subsequently brought together in the Louvre: old royal collections, collections from the Academy and lastly sculpture from the old «Museum of French Monuments», created by Alexandre Lenoir, and which comprised works dating to the Middle Ages and the Renaissance originally in churches and monasteries. These facts explain why the French school predominates in this section, even though foreign schools, at least for the fifteenth and sixteenth centuries, are not excluded.

In 1993 the redistribution of these works, at present exhibited in chronological order on the ground floor in the Pavillon de Flore and in the Gallery which flanks the Seine, will be begun in the Richelieu wing. Among the medieval works, of which the Louvre offers a brilliant panorama, particular note should be taken of the statue of **Charles V** (circa 1365-1380), a fine example of the development of realism in portraiture, and the surprising **Tomb of Philippe Pot** (late fifteenth century), supreme achievement of a type of sculpture inaugurated by Claus Sluter at the court of Burgundy.

The French Renaissance is represented by two great artists: Jean Gujon, with a fine bas-relief from the Fountain of the Innocents, and Germain Pilon, who executed the funeral monuments of king Henry II. By the middle of the seventeenth century sculptors were in the service of the monarchy of Versailles, where Classicism consisting of measure and reason dominated. Only Puget, in Provence, saved himself from the influence of the court and created a vivid and impassioned work. This Baroque influence continued in the middle of the eighteenth century as witnessed by the **Horses of Marly** by Nicolas Coustou. A tendency to return to antiquity appeared in the middle of the century, dominated by artists such as Pigalle, Bouchardon, Falconet, who created a neoclassic style, which received its official connotation from the Venetian Canova (see **Cupid and Psyche**).

▲ 14th-century French art, stone statue of Charles V from the portal of the Hospice des Quinze-Vingt in Paris.

Attributed to Antoine le Moiturier (c. 1425-c. 1497)

Tomb of Philippe Pot

The tomb of Philippe Pot, great seneschal of Burgundy who died in 1493, was originally in the abbey of Citeaux. It has been attributed to Antoine le Moiturier, known also as «maistre Anthoniet», on the basis of stylistic and compositional similarities to the tombs of Champmol in Dijon. The deceased, enclosed in a suit of armor, is carried by eight figures who are hermetically enveloped in their sombre mourning weeds. The importance of Claus Sluter for his art is also clearly evident.

Michelangelo (1475-1564)

Slaves

Sculpted between 1513 and 1520 for the base of the tomb of Pope Julius II (which was never completed), these statues were given to Henry II of France in 1550 by the Florentine exile Roberto Strozzi. Later they were transferred to the castle of Anne de Montmorency, at Ecouen, and then to that of Richelieu, finally reaching Paris where they came to the Louvre at the time of the Revolution. In Michelangelo's symbolic terms, they were perhaps meant to represent the Arts, imprisoned by Death after the death of the pope who had for so long been their protector. Above all, however, they are the clearest and most powerful expression of the restless, tormented spirit of Michelangelo in his unceasing effort to dominate the material of his art.

Baigneuse

Falconet is considered one of the masters of French eighteenth-century sculpture. The infinite grace of this bather, the delicacy of her gesture as she modestly gathers up her dress, are why this statuette has been copied and reproduced any number of times.

Edme Bouchardon (1698-1762)

Cupid Constructing a Bow from the Club of Hercules

This marble sculpture was made between 1747 and 1750 but was not well received by critics or public, who thought the features of the young model were excessively realistic. The outstanding artistic quality of the composition and the mischievous expression on the face of Cupid testify to Bouchardon's never-ending search for classical perfection.

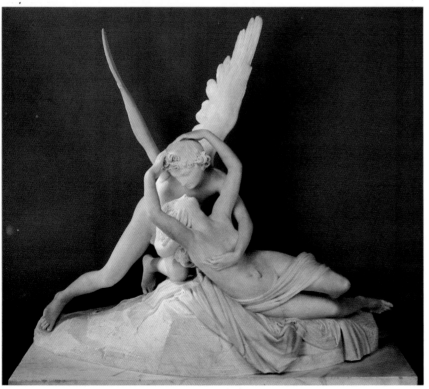

Antonio Canova (1757-1822)

Cupid and Psyche

Finished in 1793 and sold about five years later to General Murat who passed it on to Napoleon, the marble group once more demonstrates that Canova was first among the neoclassical sculptors. There is neither passion nor sensuality in the kiss with which Cupid awakens Psyche: the whole event takes place in a sphere of serenity and spirituality.

Jean-Antoine Houdon (1741-1828)

Bust of Benjamin Franklin

Houdon's powerful and expressive portraiture was popular in France at the end of the eighteenth century. This terracotta, dated 1778, is a clear demonstration of Houdon's skill in the way he has captured the ironic sly expression of the American ambassador in France, in a face but slightly touched by age, in the folds of his mouth, the lively eyes.

François Rude (1784-1855)

Neapolitan Fisherboy Playing with a Tortoise

First among the Romantic sculptors, Rude made this statue between 1831 and 1833. The naive nudity of the small fisherboy, the naturalness of the gesture, the tender bemused smile, make it one of the most felicitous of Rude's sculptural works.

Guillaume Coustou (1677-1746)

Horses of Marly

A sculptor at the royal court from 1707 on, Coustou worked on the two marble groups of horses from 1740 to 1745. They were made as replacements for the statues of Mercury and Fame by Coysevox on the north terrace of the drinking trough at Marly and were sent there by river. In 1794 they were taken back to Paris.

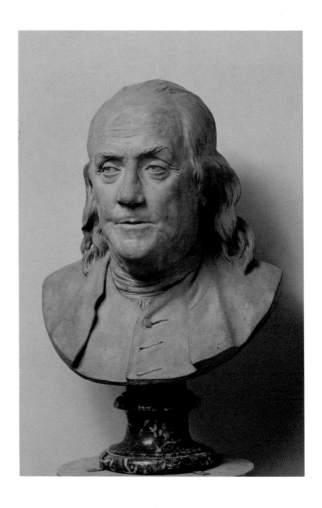

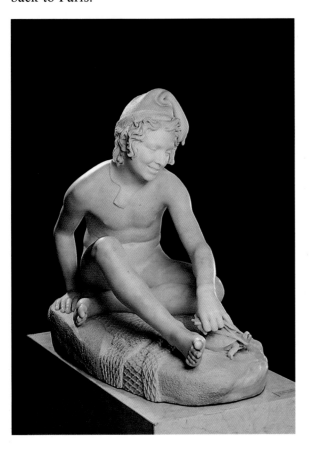

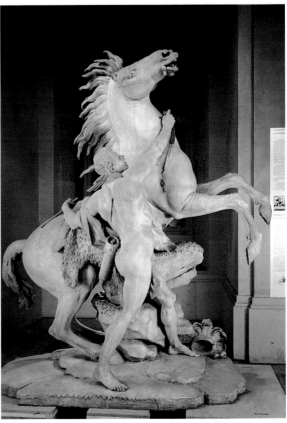

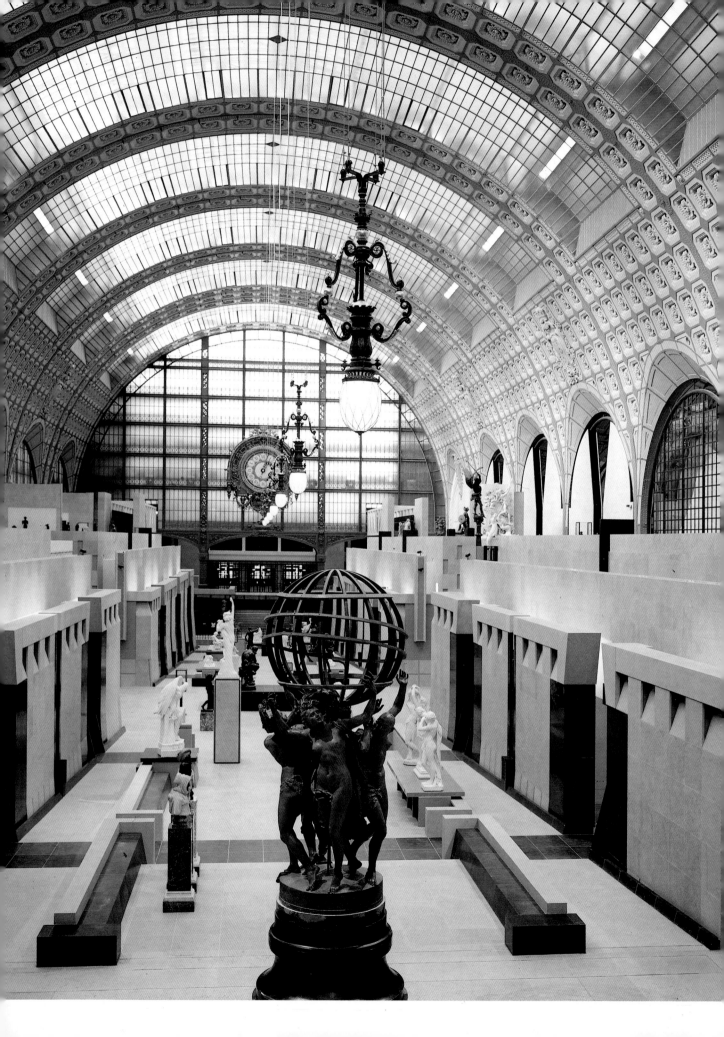

MUSEE D'ORSAY

RAILROAD STATION TO MUSEUM

The Gare d'Orsay was built by Laloux on the site of the old Cour des comptes which burned down in 1871 in the period of the Commune, the building consists of a large central concourse with metal supports, masked on the outside by a showy cut-stone facade in an eclectic style and inside by a stuccoed coffered ceiling. It became obsolescent in 1939 and when demolition threatened, in 1973 the station was included in the Inventory of Historical Monuments. This was also when, under the presidence of Georges Pompidou, it was proposed to turn the building into a museum. In 1978 Giscard d'Estaing took up the project anew and the restructuration of the station was entrusted to the équipe ACT Architecture. The transformation was concluded in 1980 by the Italian architect Gae Aulenti who was in charge of the internal architectural installations and the conversion into a museum.

THE COLLECTIONS

The Musée d'Orsay exhibits work of the second half of the nineteenth century, from 1848 to 1905 circa irregardless of expressive means or technique.
One of the principal purposes of the new museum was to gather together in one place the collections that up to then had been dispersed in various museums – the Louvre, the Jeu de Paume (Impressionists) and the Palais de Tokyo (Postimpressionists).
The origins of these collections of Impressionist and Post impressionists is in great part due to the generosity of private collectors. The first Impressionist painting to make its way into the museum of Luxembourg, meant to house works by living artists from the time of its inception under Louis Philippe, was Manet's **Olympia***, purchased in 1889 thanks to a public subscription promoted by Monet. Despite an occasional timid acquisition by the State (Renoir's* **Girls at the Piano** *and Fantin-Latour's* **Atelier aux Batignolles***), it was the large donations of the end of the century which led to the entrance* en masse *of the Impressionists in Luxembourg. In 1894, the Gustave Caillebotte bequest contained around forty pictures including Manet's* **Balcony***, the* **Gare Saint-Lazare** *by Monet, the* **Red Roofs** *by Pissarro, Renoir's* **Moulin de la Galette** *and* **Torso of a Woman in the Sun***. In 1906 the Moreau-Nélaton donation included a dozen paintings by Monet, by Sisley and Manet's* **Le Déjeuner sur l'herbe***. Lastly in 1908 the Isaac de Camando bequest was composed of a goodly number of masterworks, such as* **Absinthe** *and* **Dancing School** *by Degas, the* **Rouen Cathedral** *series by Monet,* **Fifer** *by Manet, Cezanne's* **Cardplayers** *and the* **Clowness Cha-U-Kao** *by Toulouse Lautrec.*
Other donations, such as those of Paul Gachet (works by Van Gogh and Cezanne), d'Antonin Personnaz and Eduard Mollard, were to follow.
The **Ground Floor** *is dedicated to the period 1850-1875. On either side of the concourse, in which the large sculpture from Rude to Capreaux is installed, are a series of rooms which exhibit:*
on the right: the inheritance of Classicism and Romanticism, up to the beginning of Symbolism, as well as the early works of Degas;
on the left, on the side of the Seine: Realism (Daumier, Courbet, Millet, etc.) up to the beginnings of Impressionism.
The **Upper Level** *is entirely reserved for the Impressionist painters (Monet, Renoir, Degas, Pissarro, Sisley, Cezanne) and the Postimpressionists.*
On the **Intermediate Level** *the diverse movements of the last third of the nineteenth century pass in review: Symbolism, Art Nouveau, Naturalism. On the whole, the terraces are dedicated to sculpture by Rodin, Camille Claudel, Bourdelle and Maillol.*

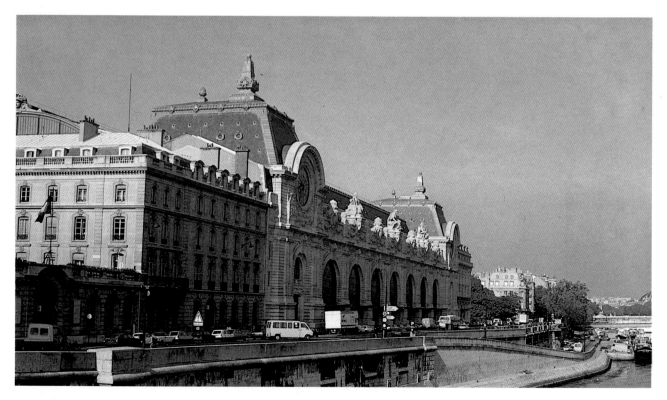

THE ART BEFORE 1870

CLASSICISM AND ROMANTICISM

The itinerary of the visit to the Musée d'Orsay begins with an homage to Ingres and Delacroix, the two leading personalities who embodied the conflict between Classicists and Romanticists during the first half of the nineteenth century.

A disciple of David, Ingres was the absolute master of the elegant flowing contour with a predilection for undulating lines. **La Source** *(1856) is the most famous example of this love for a subtle use of sfumato and sinuous forms, shared by his disciples Hippolyte Flandrin and Amauray-Duval. Diametrically opposed is the technique of Delacroix, which Baudelaire so greatly admired, describing it as «an authentic explosion of colours». Representatives of this movement in the field of sculpture were talented artists such as François Rude (see* **The Awakening of Napoleon***), Augustin Preault or Barye.*

Chasseriau, disciple of Ingres and admirer of Delacroix, attempted to reconcile the two rival schools in drawing and colour. His large decorative paintings influenced artists such as Puvis de Chavannes (see **Girls on the Beach***) and Gustave Moreau (see* **Orpheus***), whose poetical, mysterious, other-worldly paintings foreshadowed the late nineteenth-century Symbolist works.*

REALISM

Around 1848 a reaction against Romancitism began to emerge: Realism. It tended towards a more faithful imitation of nature and aspired to bear witness to daily reality, social truth. Corot and the Barbizon School (Paul Huet, Théodore Rousseau, Diaz, Troyon, Daubingny) were in a sense the link between the two movements. While their roots lay in Romanticism, eventually the affirmation of realistic veracity and a worship of nature became manifest in their works. In their attempts to capture the intense impalpable vibrations of light, they were the harbingers, above and beyond Realism, of the future Impressionist movement.

*Realism found its great champion and theoretician in Courbet. His two great compositions (***Funeral in Ornans** *and* **The Artist's Studio***), refused by the Salon juries of 1850 and 1855, give full play to all his talents as colourist and portrait painter. Millet and Daumier are the other two great figures who attempted to transfer their social ideas into their works. A vigorous and synthetic line delineates Millet's peasants, subjects considered subversive in the Second Empire, in broad and static monumental silhouettes imbued with inherent majesty (see* **The Gleaners***). This three-dimensional synthesis which refuses anecdote is also to be found in the caricatures of Daumier, painted in broad powerful masses (see* **Celebrities***).*

The Gleaners

This canvas was painted in 1857 in the French village of Barbizon, where a group of painters who wanted to observe and portray nature with new eyes had gathered as early as 1848.

Millet has depicted three women gleaning in the sunny countryside of Chailly. They are not beautiful, nor even graceful. They are solid peasants, dressed in rough threadbare clothing. But they are real, authentic, and their gestures are slow, noble, almost ritual.

Exhibited at the salon, the public was quick to criticise the painting and the press accused Millet of creating revolutionary socialist art!

Jean-Auguste Ingres (1780-1867)

La Source

This work, finished in 1856, is one of the last to be painted by Ingres. By this time he was famous and celebrated and had an atelier with numerous disciples who adored him, despite his moody character and occasionally abominable behaviour.

This splendid female nude was unanimously received with enthusiasm: one might even say that here the sinuous line of the body, which had already found expression in odalisques and bathers, achieved an absolute perfection and harmony.

Bather at the Spring

The name given to the movement headed by Gustave Courbet was derived from the title of a one-man show that opened in Paris in 1855 («Realism, G. Courbet»). What he was aiming for in his works was not grace, but only truth. Yet when he portrayed this village beauty on canvas, with her broad solid hips, it created a scandal, and a critic defined her as a «Hottentot Venus with monstrous buttocks».

The Artist's Studio

Courbet himself defined this painting as «a true allegory of seven years of my artistic and moral life». He shows himself in a large room, real and unpretentious, painting a large landscape, inspired by Truth, the nude woman behind him. Recognizable on the right are Baudelaire, Proudhon, the art patron Bruyas, the writer Champfleury. The others are put on the left, «the other world of banal life, the people, misery». All the life, the ideas, all the people who were important for Courbet in his artistic vicissitudes are present in this picture, refused at the 1855 Salon but which Delacroix called one of the most remarkable works of the time.

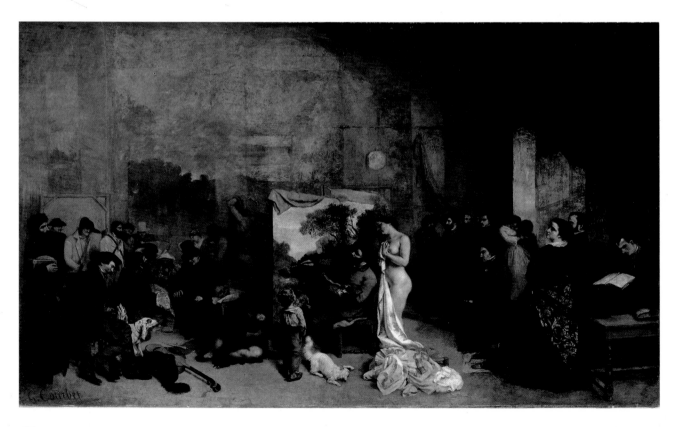

Gustave Moreau (1826-1898)

Jason and Medea; Orpheus

The precious refined art of Gustave Moreau, in its wealth of details, complexity of vision, and pervasive atmosphere of mysticism, has many points of contact with Symbolist poetry.

Much is said about Moreau's painting in a chapter of Huysmans' book «A rebours», written in 1884 and considered the «bible of decadentism». Des Esseintes, the protagonist of the novel, is attracted by «those despairing erudite works, which emanate a singular spell, a fascination which is deeply, intimately, disturbing...».

Like many other symbolist painters, Moreau was also drawn to the myth of Orpheus and after lengthy preparatory studies he painted this picture in 1865. He had arrived in Rome in October 1857 where for several months he applied himself to a study «trés sévère de ton et de forme» of Sodoma's large fresco of the *Marriage of Alexander and Roxana*. But while the figures of Jason and Medea are directly inspired by those of the episode of Hymen and Hephaistion, the quotations from Leonardo in the landscape in the background on the left, recalling that in the *Virgin of the Rocks*, is not to be overlooked and the pose of Medea resembles that of *Leda*. The scroll that is wound around the column bears verses from Ovid's *Metamorphosis*.

Quotations from antiquity are also to be found in the other picture by Moreau, the *Thracian Girl Bearing the Head of Orpheus*. It is said that Moreau was inspired by the head of one of Michelangelo's prisons when he painted that of the bard laid against his lyre. In both paintings the glowing colors, the intimations of mysticism and sensuality, the mysterious surreal landscapes create a magic dreamlike atmosphere.

Jean-Baptiste Carpeaux (1827-1879)

Ugolino and His Starving Sons

Romantic artists, of whom Carpeaux is one of the best representatives, frequently found inspiration in the theme of Count Ugolino and his terrible story. This bronze group was made in 1862 in Rome, the site of Michelangelo's *Last Judgement* and of the *Laocöon* whose influence is clearly reflected here, albeit transfigured. There is something terrible in the drama of this powerful work.

Honoré Daumier (1808-1879)

The Parlamentarians
or The Celebrities of Juste-Milieu

His consummate skill as a caricaturist and a keen eye focussed on society and daily life lie at the basis of the series of thirty-six terra-cotta busts painted in oil depicting well-known figures in the Paris scene of politics and culture which Daumier began in 1831. Scathingly forthright, the artist reveals the true nature of these personages, their vices, the hidden aspects of their personalities, their tics.
Two of these were the journalistic Charles Philippon (on the left) and the Minister of the Interior Guillaume Guizot (on the right).

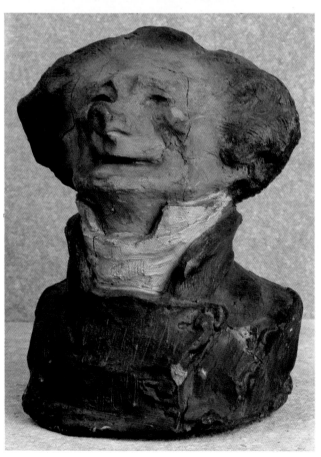

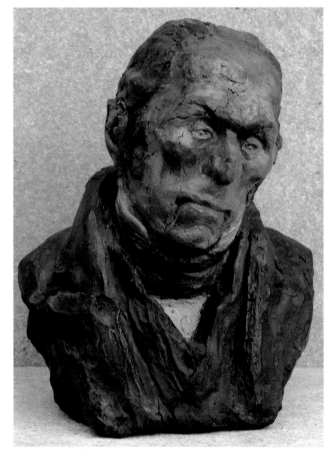

Ernest Meissonier (1815-1891)

The Traveller

Famous above all as a painter of historical and genre subjects, Meissonier clearly attempted to imitate the Dutch masters, but despite his great ability and indiscutible professionality, he never succeeded in equalling the great painters who had inspired him.

His attempts at sculpture were more pleasing and spontaneous, as in this precisely modelled Traveller in polychrome wax: the human figure is dressed in cloth, the horse's bit is in metal and the bridle in leather.

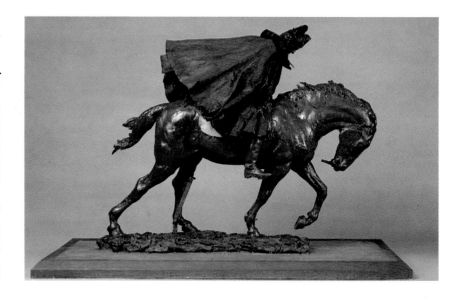

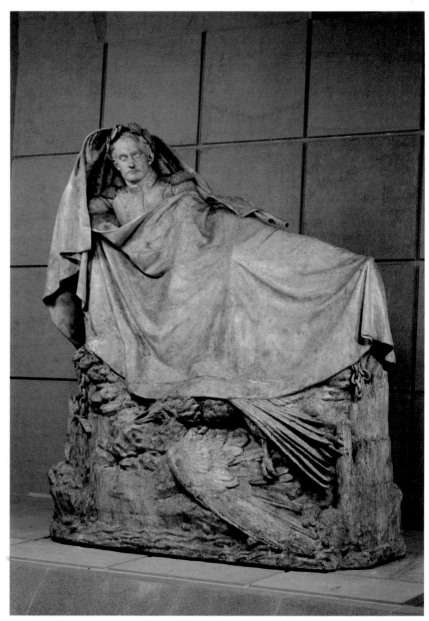

François Rude (1784-1855)

The Awakening of Napoleon

A romantic François Rude, who found inspiration in the personage of Napoleon rising from his shroud to enter immortality.

The final bronze version is in the park of Fixin, in Burgundy, and was commissioned by a certain Noisot, former commander of the Grenadiers on the island of Elba.

THE IMPRESSIONISTS BEFORE 1870

The painters who can be grouped together from 1874 on under the term of Impressionists all came from the Realist movement in which observation from nature was stressed.

Influenced by the English painters (Constable, Turner, Bonington) and by the Barbizon school, Jongking and Boudin captured the fleeting effects of atmospheric changes in their works. Boudin's limpid painting, describing the vibrations of light in his views of the beaches of Normandy, animated by the elegant crowd of summer excursionists (see **Beach of Trouville**)*, profoundly influenced the young Claude Monet, whose family had gone to live in Le Havre. Without breaking with the classic concept of drawing and colour, Degas and Manet were to be the two great precursors of Impressionism thanks to the way in which they used colour. When Manet's* **Dejeuner sur l'erbe** *and the* **Olympia** *were presented at the Salons of 1863 and 1865 they aroused a downright scandal, both on account of the subject matter, judged immoral and provoking, and in the brutality of the style. Manet's breaking up of the masses by means of strong contrasts of colour and light makes him a «primitive» of a new era. The works by Degas, on the other hand, manifest a masterly play of chiaroscuro, with strong contrasts of dark but refined colours (see* **The Bellelli Family**)*and a bold composition (see* **The Orchestra de l'Opéra**)*.*

At the beginning of the 1860s, Monet, Bazille, Renoir and Sisley met in the atelier of Gleyre where they became friends. Sharing the same ideas and attracted by the realist current, they continued their own studies on light in the forest of Fontainebleau, in the wake of the painters of the Barbizon school. Following Manet's example, in 1865 Monet created a free technique in which the spontaneity and freedom of the sketch was maintained in an attempt to achieve the fleeting effect of light filtered through the leaves, with broad areas of light and shade speckling the figures gathered together in a glade. The artist's early style, which appears in **The Picnic** *(1865-1866) and in his* **Women in a Garden** *(1867), was to undergo a profound transformation around 1870.*

Closely tied to Monet, Bazille concentrated his attention on the figure, strongly lit by a blinding light which accentuates the contrasts (see **Family Reunion**)*.*

Close to Manet and the Impressionists whom he admired even though he never participated in the movement, Fantin-Latour can be considered a personality apart, gifted with a keen sense of observation. His **Atelier aux Batignolles** *(1870) is inundated with a soft subtle light which envelops the figure in somber severe tonalities.*

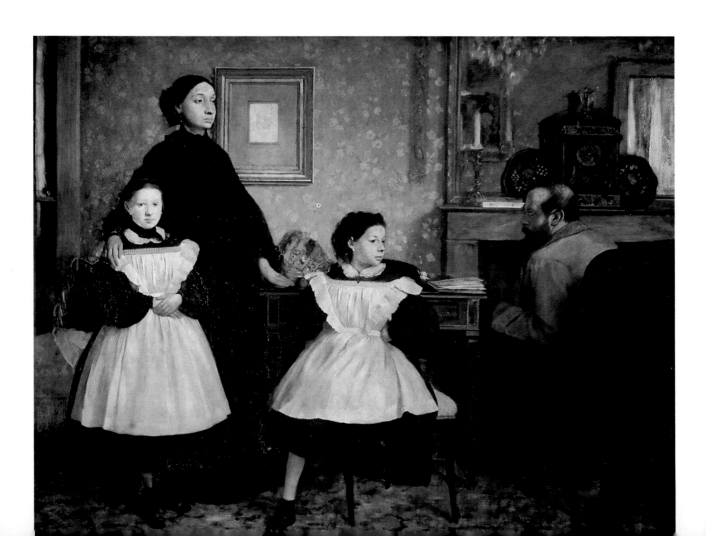

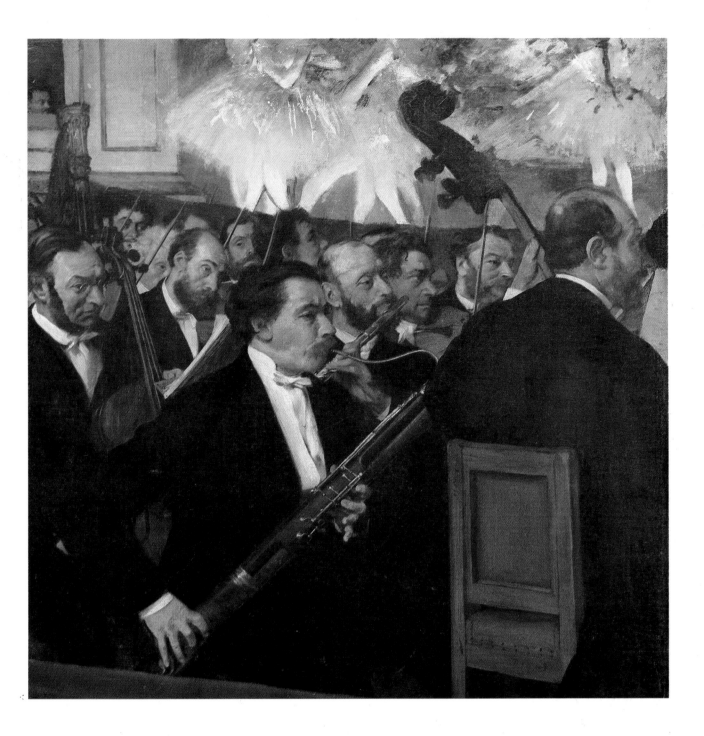

Edgar Degas (1834-1917)

The Bellelli Family

Begun in 1858 when he was staying with an aunt, Baroness Laura Bellelli, in Florence, the painting is simple and severe in its composition. The novelty behind the concept of this work is to be found in Degas' own words: «...I want to depict people in familiar and typical poses». Based almost exclusively on the play of blacks and whites, the composition is enhanced by the perspective which the reflection in the mirror over the mantelpiece opens up.

Orchestra at the Opéra

This is one of the first paintings in which the world of the Opéra and the ballet, so dear to Degas who depicted it countless times, was to appear. It is a magnificent depiction of this milieu, with the violent contrast between the semi-darkness of the orchestra and the brilliantly lit stage.

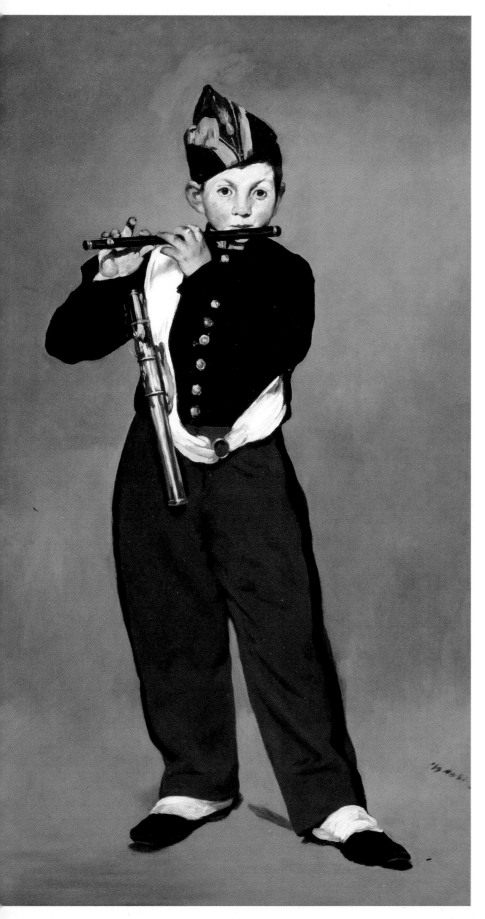

The Fifer

In view of the concept of art that still prevailed in France at the time this picture was painted, it is not surprising that it was refused at the Salon of 1866. Totally lacking in shadows and background, Manet's extremely synthetic and vigorous figure almost looks like a cut-out and owes his form to the lively juxtaposition of the limited range of colours used.

Olympia

«What is this odalisque with her yellow belly?» exclaimed a critic confronted with Manet's Olympia at the 1865 Salon. The picture, painted in 1863, scandalised the public and the official critics: it was inconceivable at the time for a female nude to be painted with a technique which was so irreverent towards the then accepted artistic canons. And Manet indeed makes a total break with tradition: he destroys volume and abolishes all the intermediate colour tones and the half-tints, relying only on a free association of colour tones. The result is thus a very flat style of painting, in which every element is simplified to the point of pure abstraction.

Déjeuner sur l'herbe

Painted in 1863, the picture was thought scandalous and refused at the Salon: on this occasion a supplementary salon, which was to pass into history as the «Salon de Refusés», was opened.
The subject is classical and was inspired by ancient art. All the great Venetian painting, and in particular Titian's *Concert Champêtre* immediately come to mind. But the revolutionary novelty is that Manet transferred the subject into everyday life, placing a nude female figure between two men, two intellectuals, who are amiably conversing. The technique is as revolutionary as the content: Manet completely abolished chiaroscuro, eliminated half tones and directly juxtaposed the luminous tones.

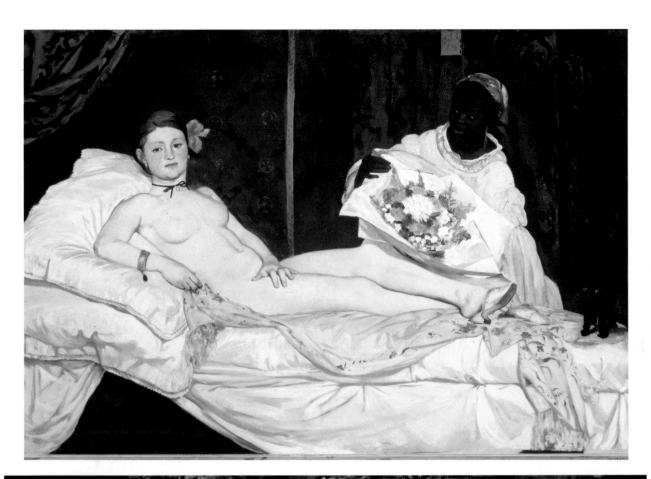

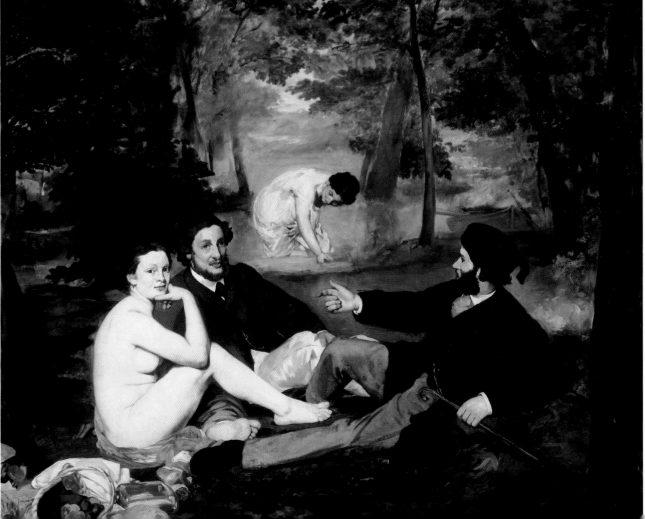

Claude Monet (1840-1926)

Women in the Garden

This canvas was painted in 1867 in Ville de Avray «en plein air» and reveals how profound Monet's study of the effects of light were. The sun stands directly overhead and the light falls perpendicularly on this flowering garden: the blinding white skirts, the path, the umbrella – all seem to have been cut in two by shade and light.

Frédéric Bazille (1841-1870)	*Eugéne Boudin (1824-1898)*
Family Reunion	**Beach at Trouville**

The almost photographic impression given by this picture is that of a family «in pose», with each individual bathed alike in a bright light that accentuates the volumes.

The ever-changing skies and iridescent sea, typical of the coast of Normandy, fascinated Boudin, who found the primary inspiration for his painting in this shifting play of light.

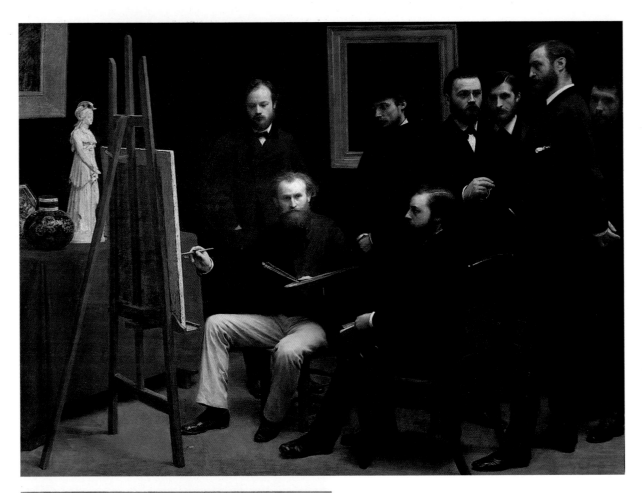

Henri Fantin-Latour (1836-1904)

Ateliér aux Batignolles

This canvas, a fond homage to his friend Manet, contains a real gallery of portraits. Fantin-Latour depicted the painter in his studio surrounded by friends: Monet, Bazille, Renoir, the writer Emile Zola, the art collector Edmond Maitre, the man of letters Zacharie Astruc and the other painter, Otto Scholderer.

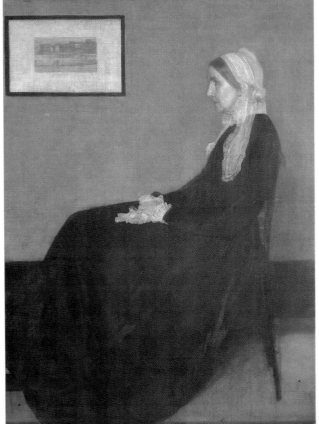

James Abbot McNeil Whistler (1834-1903)

The Artist's Mother

The American painter Whistler said that what interested him in this picture was the fact that it was the portrait of his mother, whereas it should be of interest to the public on the basis of the merits of the composition. The painting, exhibited at the Royal Academy in London in 1872 under the title «Harmony in Grey and Black N. 1» was, however, not well received. Valiantly defended by its most tenacious champions, including Clemenceau and Mallarmé, it was finally accepted by France and purchased in 1891.

THE IMPRESSIONISTS

The official date for the birth of the movement was 1874, the year in which, on the occasion of the first independent exhibition of the group, they were first called «Impressionists», after a painting by Monet entitled **Impression-Sunrise**.

After the war of 1870 Claude Monet was considered the head of the movement: he established himself at Argenteuil, where almost all of them, including Manet, went to work, and began to describe the vibrations of light on the landscapes along the banks of the Seine. In his attempts at expressing a momentary vision that was dependent on the ephimeral effects of a light that constantly changed with the passing of time and the seasons, he dissolved matter, annihilating its density, in a play of fragmentary ever-changing brushstrokes (see the series of **Rouen Cathedral***). Close to Monet, Sisley (see* **Flood at Port Marly***) and Pissarro (see* **Red Roofs***) bathed their landscapes of the Ile de France in a delicately coloured light.*

Renoir, on the other hand, attempted to apply the principles of Impressionism to the study of the human figure. In the **Torso of a Woman in the Sun** *and in the* **Moulin de la Galette***, the figure vibrates under the effect of the manifold reflections of light rendered by means of small fragmented spots which are scattered over the skin and the clothing.*

An independent artist, passionately interested in photography, Degas invented a new concept of the framing of the picture, often off center (see **L'Absinthe***) which depicts the figures in their immediate reality. Gradually moving towards the new studies on colour and artificial light in the esclusive world of the Opéra, his figures are blanketed in a dense rich layer of warm sparkling tones (see* **The Blue Ballerina***).*

Cezanne, on the other hand, had a distinct personality of his own and wanted «to turn Impressionism into something solid and lasting like the art in museums». He was less interested in rendering fleeting impressions than he was in grasping the permanent character of things, by means of an exemplification and synthesis of the forms, powerfully modelled by small colourful brushstrokes set one next to the other, borrowed from the tecnique of the Impressionists.

THE POSTIMPRESSIONISTS

In the 1880s a crisis arose within the Impressionist movement itself. Renoir, who had never abandoned the human figure, hoped for a return of drawing, of contour, of form, condemned in the name of the primacy of colour (see **Dance in Town***). In these years Cezanne began a simplification of volumes tending towards a geometric and prismatic expression of the forms thus heralding, beyond Postimpressionism, the cubist revolution of the twentieth century.*

A few young artists however oriented the movement towards new horizons. In his search for the static position of the forms, Seurat applied a new method in his painting. Known as «neoimpressionism» (or «pointillism»), it consisted in placing on the canvas small dots of juxtaposed colour, meant to intensify the solidity and vivacity of the colours themselves (see **The Circus***). Gauguin, on the other hand, gradually gave up Impressionism for a more solid style with greater contrasts, using broad areas of uniform colour, «inserted» or «synthetic», which enhanced the uniform purity of the intense flaming colour (see* **Women of Tahiti***). As for Van Gogh, he reinforced the expressive power of contrasts of complementary colours, distributed in powerful swirling brushstrokes which made him a precursor of the Fauves and the Expressionists in the following century.*

Degas and Japanese prints strongly influenced the eccentric figure of Toulouse Lautrec who left his mark in the vigour of his incisive and expressive drawing which boldly renders the momentary gesture and pose of the model in its essence (see **The Toilette** *and* **The Clowness Cha-U-Kao***).*

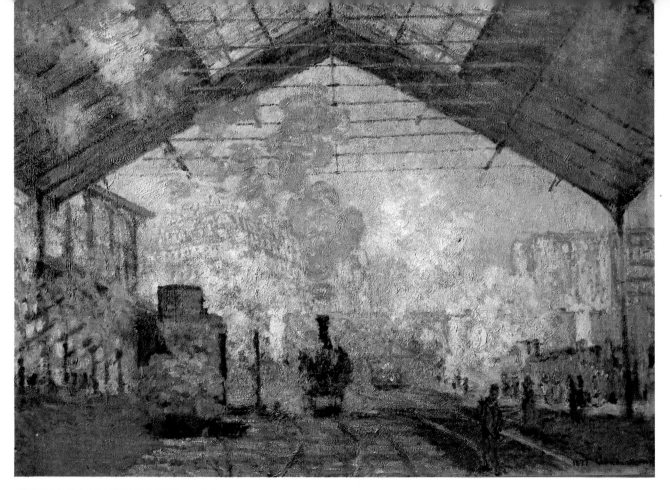

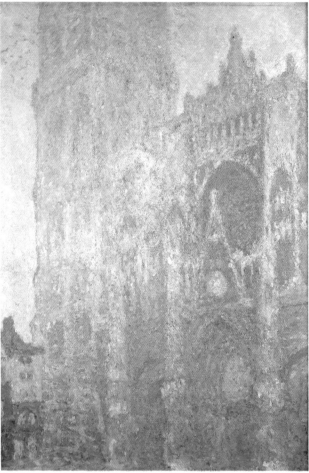

Claude Monet (1840-1926)

La Gare Saint-Lazare; Rouen Cathedral

It was while he was staying in Giverny that the idea of painting the same subject repeatedly as it was transformed by the passage of time – the hours, the seasons – and light came to Monet. He dedicated seven canvases to the Station of Saint-Lazare and more than twenty to the Cathedral of Rouen. What fascinated him particularly in Saint-Lazare was the effect of the light as it shone through the high glass roof and blended with the steam and smoke of the trains entering the station; in Rouen it was the ever-changing play of light throughout the day as it modified and transformed the reliefs and statues on the facade and the portals, stressing now one, now another detail.

Woman with an Umbrella Facing Left

Once more Monet captures on canvas the effects of light on the human figure. A woman in the midst of a field of flowers and the light which surrounds and completely envelops her.
Features and details are just barely hinted at, and all that remains of the figure is an impression of weightlessness and luminosity.

Auguste Renoir (1841-1919)

The Moulin de la Galette
Torso of a Woman in the Sun
The Dance in Town

There is an episode in Renoir's life that is particularly important for an understanding of his relationship to painting. One day he was asked if it was true that he painted for pleasure. Renoir, who at the time was in his twenties, answered that if he didn't enjoy painting, he wouldn't paint at all. This is just what Renoir's painting is: pleasure, joy, a total happy participation in the world of men and things. Colour, light, life: these are the three components always present when the painter approached his canvas and set down his emotions. Daily life is depicted in its most commonplace aspects: a woman reading, a couple dancing, a gay open-air restaurant at the top of the Butte Montmartre.

But if all this was to be gay and spontaneous, lifelike and real, the past had to be abandoned, liberating painting from the effects of chiaroscuro and the resulting cold and conventional painting.

This was precisely the effect provided by the forthright juxtaposition of colours, and the elimination of half tones: the outlines of the figures and objects almost seem to have been dematerialized and the painting is nothing but a succession of spots of light and coloured shadows, furnishing the onlooker with an impression of movement, animation, in a word, life. Thus, in this carefree dance under a pergola, one can sense the rays of sunlight coming through the leaves and touching details here and there – a face, a corner of a chair, a straw hat. The same thing holds for the torso of the woman which lazily emerges from the green of a garden, with a scattering of luminous spots, so that one really seems to feel the warmth on the skin. Just as one seems to hear the rustle of satin in The Dance in Town, where a greater attention to line derives from a rediscovery of Raphael during a trip to Italy.

Renoir was never to abandon the theme of contemporary life in its multiple everyday aspects and was to leave the mark of his greatness there. Painters as in love as Renoir with the things they painted are few indeed. His is a hymn to life and, somehow, miraculously, he managed to transmit it to others.

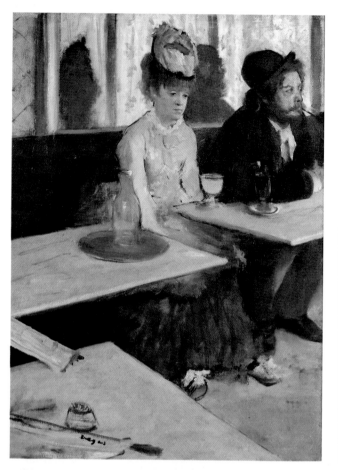

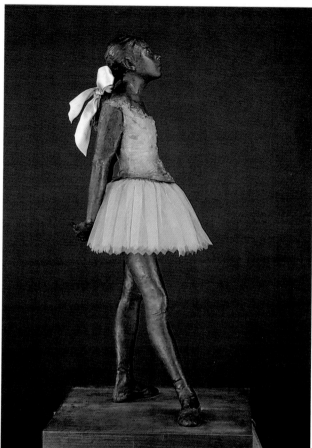

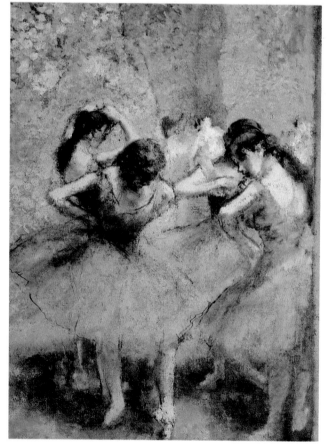

Edgar Degas (1834-1917)

Absinthe

The world of Degas was not limited to the glittering milieu of the Opéra and ballet; the painter was also a habitué in the world of the cafés with a dejected, suffering, solitary humanity. The influence of Japanese prints and a remembrance of Dutch interiors are at the base of this picture of 1876, where the daring introduction of a table catercornered to the frame gives it a photographic effect.

Large dressed Ballerina

In 1881 Degas also began his studies in sculpture but he did so only as an exercise, so that his painting might improve thanks to a more thorough study of form and pose. There is great realism in this fourteen-year old ballerina of his, in bronze, dressed in a tutu of white tulle and with a large pink satin ribbon in her hair.

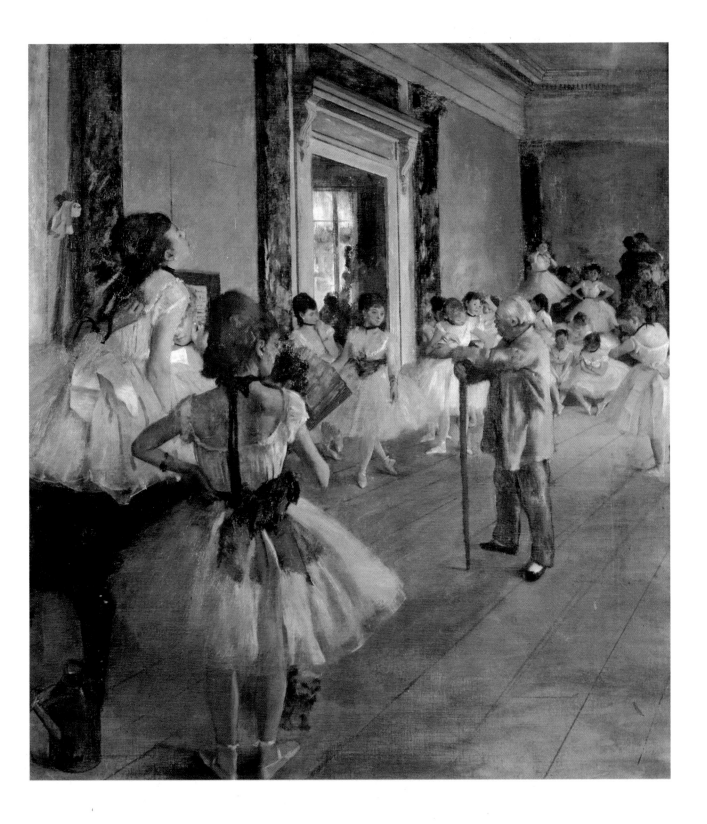

Dancers in Blue; The School of Dance

Bold framing, unusual views and a brilliant colourful palette: the impalpable tulle of the tutu, the nervousness while waiting to go on stage, and the exhaustion in the dressing room after the curtain has fallen.

This is the world of the Opéra, of dance lessons, of the performances, a world Degas explored and studied even in its most intimate and subtler details. Degas observes and describes: as in the ballerina dressed in blue tightening her dress before beginning her performance, or the one who takes advantage of a pause and massages her aching back without any particular grace but with the utmost naturalness.

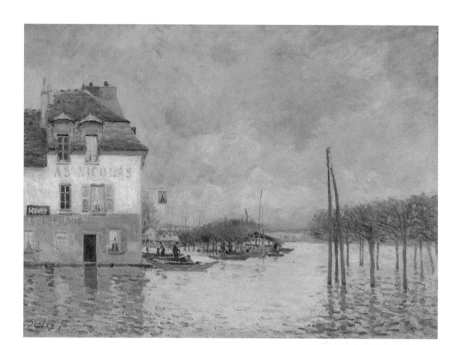

Flood in Port-Marly

Sisley was the only one of the Impressionists to be a rigorous landscape painter. A critic defined his landscapes as «the most exquisite of the Impressionist school». The painter is emotionally involved as he depicts this desolate stretch of water, this leaden sky still swollen with threatening rain. Sisley devoted many pictures to the floods which struck the village of Port-Marly and his main interest was in capturing on canvas the changing nuances of light.

Paul Cézanne (1839-1906)

Woman with a Coffeepot
The Cardplayers
Apples and Oranges
Still Life with Onions

«When colour has its richness, form has its perfection» Cezanne was apt to repeat with regard to his painting. Within the revolutionary group of the Impressionists, Cezanne carried on his own personal revolution: while painters like Renoir, Degas, Manet captured the impressions

of a moment on their canvases, Cezanne presented nature in its immutability and eternal identity; while with the Impressionists forms had lost their contours, they were recreated and reconstructed by Cezanne.

What he wanted most was to express solidity and depth: in his attempts to achieve this aim he completely forgot Brunelleschi's linear perspective and created a new perspective all his own, showing the objects from above and from various points of view at one and the same time.

Volume once more became a dominant element in the composition, which was no longer created by line but by the play of freely juxtaposed colour planes. And this is why Cezanne has been called the «solidifier of Impressionism». He obviously preferred still life as subject matter, but when he painted the human figure it was treated as if it were a still life and the bodies became monumental, three-dimensional, essential in their geometric forms. On the other hand it has been said that Cezanne saw nature in terms of «cylinder, sphere, cone». While all this led to heavy irony on the part of the public and the critics, it is also true that this is what made Cezanne the father of modern art: his geometric forms and essential structures were assimilated and transformed, first by the Fauves, and then by the Cubists.

111

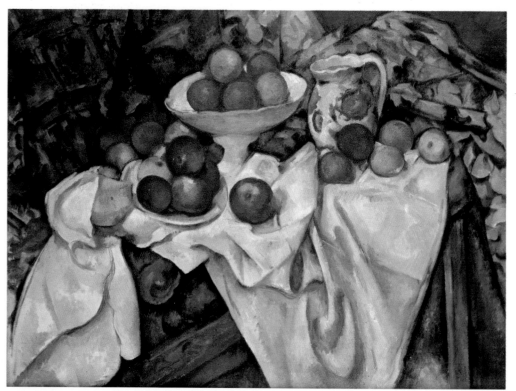

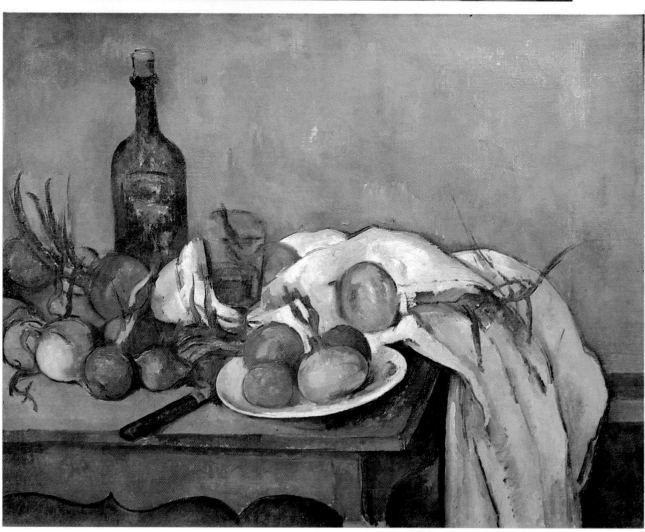

Camille Pissarro

Red Roofs

Within the panorama of the Impressionist school, Camille Pissarro has his own independent personality, though it was without doubt derived from the contacts which he had first with Monet and later, more importantly, with Cézanne. Manet stayed with Cézanne at Pontoise in 1877, and during this period of work together Pissarro gave much to Cézanne and at the same time received much from him. This work, dating from the period with Cézanne, gives us the exact impression of an autumn landscape, when the trees are bare and the dry shrubs and the ground are strewn with a mantle of red and golden leaves. A glimpse can be had, between the twisted branches, of the sharp red roofs of a small village, the structure of which remains solid and compact despite the restless glimmerings of light and the rapid touches of the painter's brush.

Henri Toulouse-Lautrec (1864-1901)

The Clowness Cha-U-Kao; The Toilette

Linked to no particular school or artistic movement, Henri Toulouse-Lautrec remains, among the most important exponents of Impressionism, the artist who was least touched by the polemics which raged in the cafés and studios of Paris during those years, so important for the formation of modern art. Concealing his deformed figure in the smoky, noise-filled night spots of Montmartre, he sat at a table all night, rapidly sketching on paper not only the physical but also the psychological aspects of the characters who alternated on the stage: the elegant and refined Jean Avril; la Goulue, the washer-woman who became the prima ballerina at the Moulin Rouge; the celebrated Valentin le Désossé («the Boneless»); and the female clown, Cha-U-Kao, a pathetic personality from this world of poor players who, even in her gaudy costume, reveals a gentle humanity and a sad sense of resignation.

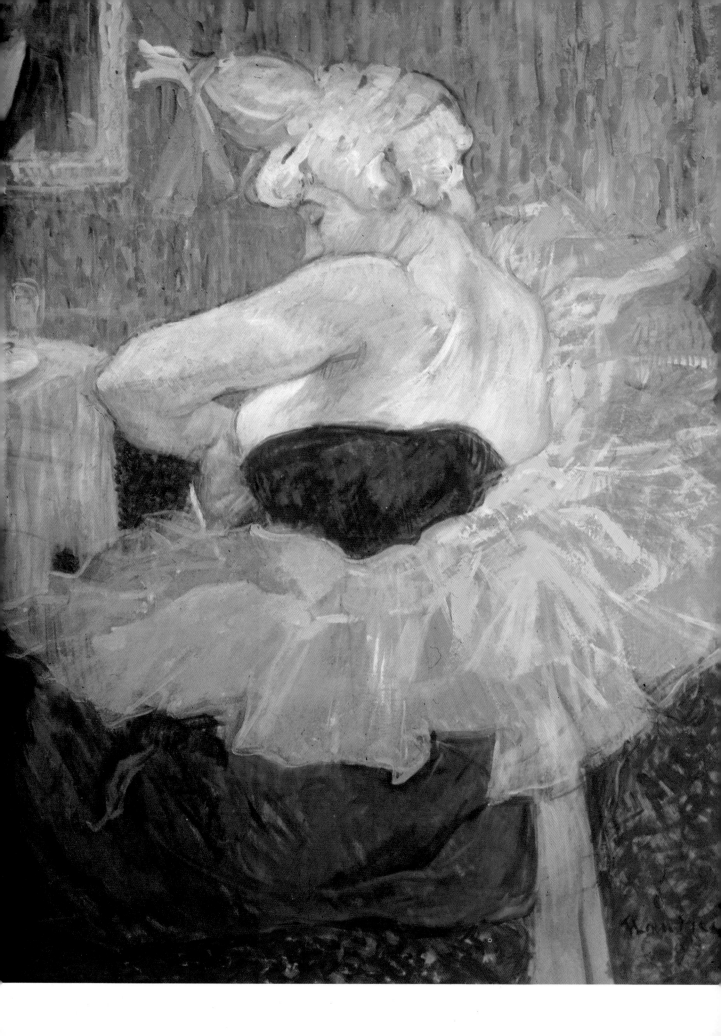

116

Vincent Van Gogh (1853-1890)

Self-portrait
Van Gogh's Room
Dr. Gachet
The Church of Auvers

In the history of culture and art, the personality of Vincent Van Gogh is overwhelmingly apparent. Mentally ill and a man of genius (but has madness ever generated genius?), this artist was the epitome of the Bohemian painter living on the verge of desperation and hope. As with no other painter, the various stages in Van Gogh's life are set before us in his works. His pictures mirror his brief periods of serenity and of exaltation, the rare respite of happiness and the many moments of sorrow and pain. *Self-portrait* and the *Room* were painted in 1889 in Provence, where Van Gogh had arrived the year before in his search for sun and light. The former was painted in the insane asylum of Saint-Remy, where the painter had gone voluntarily after a period of prolonged crises, marked by attempts at suicide and hallucinations. Van Gogh was confined to his room for a long time and thus could paint nothing but figures: the supervisor of the asylum and two self-portraits, including this one where he is «thin, pale

as a devil».
The other picture, of his room in the «Yellow House» in Arles, is more serene. This was his last refuge, a hope and a safe haven. He wanted the furnishing to be as simple as possible, almost like a monk's cell, and only the colour, as he wrote his beloved Theo, was to «...suggest the calm of sleep. The walls are pale purple. The floor is covered with red bricks, the wooden bedhead and the chairs are as yellow as fresh butter, the sheets and pillows are a light lemon yellow. The coverlet is scarlet. The window green. The dressing table orange in colour, the basin blue. The doors lilac. Portraits on the wall, a towel and a few articles of clothing».
The end of the artist's life was drawing near: the painter would soon leave Provence, and this feeling of quiet and rest would disappear from his canvases, just as the yellow which obsessed the painter would also disappear: «...yellow, pale sulphur yellow, pale lemon, gold. How beautiful yellow is!» It was still to appear in the never-ending fields of windswept wheat but overhead there would be the black flights of crows and troubled stormy skies. The colour blue predominates in the *Church of Auvers*, the town where the painter was to commit suicide on July 28, 1890. He was to write his sister Wil: «...I have painted a large picture with the village church, in

which the building looks purple against the deep blue sky, pure cobalt; the stained-glass windows look like spots of ultramarine blue...»

In Auvers-sur-Oise there was also the comforting presence of Dr. Paul Gachet, who took Vincent under his protection. For Van Gogh he immediately became a model to paint, with that «desolate ex-pression of our times» and «...a face hardened by grief». He portrayed him leaning on a red table, with a white cap on his head, «very blond and very light». Sadly enough, not even the loving presence of so many friends was to be of any help in keeping at bay the tragic destiny which Van Gogh himself was slowly constructing.

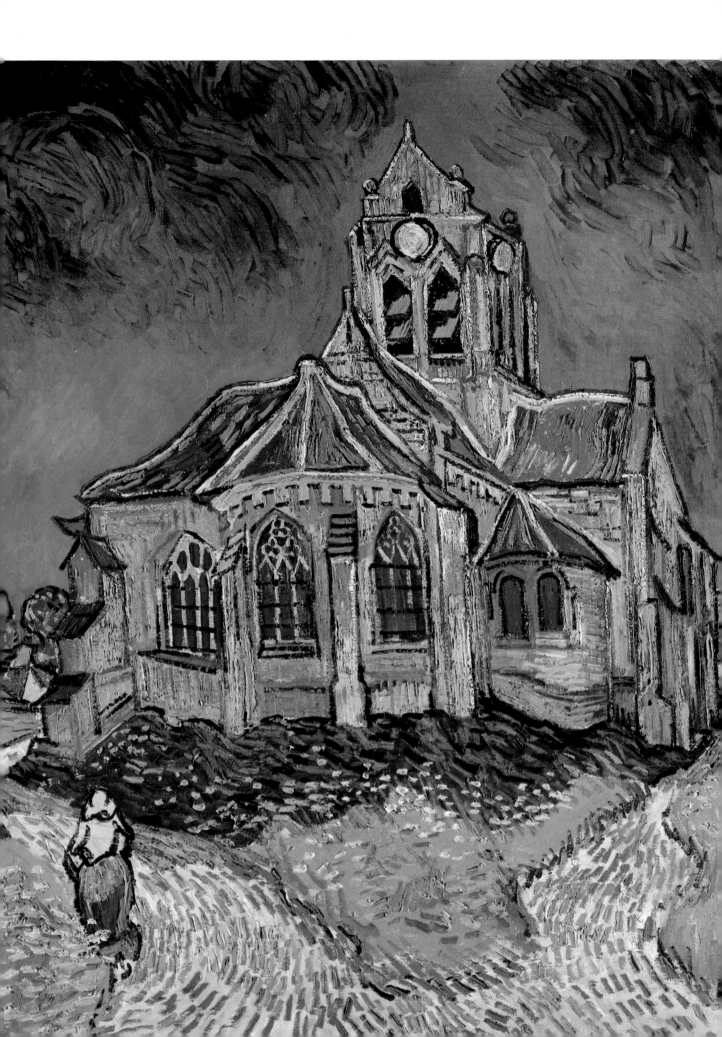

Carved wooden Mask

This carved and polished wooden mask shows us the gentle chubby features of Teha'amana, Gauguin's «vahine», who appeared as Tehura in the painter's book «Noa Noa». This beautiful Polynesian girl who was to be the artist's silent and faithful companion, and above all the model for his finest works, was barely thirteen when Gauguin first met her.

Tahitian Women

Gauguin's art has all the appearance of a flight from civilisation, of a search for new ways of life, more primitive, more real and more sincere. His break away from a solid middle-class world, abandoning family, children and job, his refusal to accept easy glory and easy gain are the best-known aspects of Gauguin's fascinating life and personality. This picture, also known as «Two women on the beach», was painted in 1891, shortly after Gauguin's arrival in Tahiti. During his first stay there (he was to leave in 1893, only to return in 1895 and remain until his death), Gauguin discovered primitive art, with its flat forms and the violent colours belonging to an untamed nature. And then, with absolute sincerity, he transferred them onto canvas.

Arearea

Gauguin almost always put the title of the painting on the canvas in the Maori tongue. Arearea means Joy, but the picture is also known as «The Red Dog». The colour of the dog in the foreground in particular was what scandalized visitors to the Duran Ruel exhibition of 1893 where Gauguin had exhibited this painting. One girl plays the «vivo», the Tahitian flute, and another girl sits underneath a tree; further back several tamurè dancers are in front of a Maori idol. The scene is filled with a great serenity and peace – a peace Gauguin had never succeeded in finding in Paris, nor in Provence, nor in Brittany.

Georges Seurat (1859-1891)

The Circus *(on the following pages)*

Seurat, one of the major representatives of Post-Impressionism, decided to apply to his art the results which the scientific research of the period had achieved in the fields of optics and physics. Conscious of the fact that colours near each other in the spectrum influence each other (a law formulated by Chevreul), Seurat created so-called Divisionism or «Pointillisme», a technique in which he covered the surface of the canvas with dots of colour, achieving effects of great lightness and luminosity. This painting, dating from 1890, was exhibited at the Salon des Indépendants the following year: as it happened, Seurat died suddenly in March of the same year, during the exhibition, and the painting, which was uncompleted, remained at the stage of a coloured drawing.

SYMBOLISM AND ART NOUVEAU

SYMBOLISM

Symbolism developed as a reaction to nineteenth-century Realism.
The Symbolist movement was most directly influenced by Puvis de Chavannes with his large spare but poetic compositions with their clear fresh colours. This reconquest of the art of the unconscious and the dream was carried to its term by Odilon Redon (see **Closed Eyes***).*
In England the Pre-Raphaelites affirmed their rejection of reality and their desire to return to the Gothic art of the early Renaissance (see the **Wheel of Fortune** *by Burne-Jones).*
A complex personality who occupies a place apart, his desire to express an inner world dominated by a devastating passion relates Rodin to the Symbolists (see The **Door of Heel***) this same passion animated Camille Claudel in his masterpiece,* **Maturity***, inspired by the break with Rodin. At the beginning of the twentieth century, Bourdelle (see* **Penelope***) and Maillol (see* **Mediterranean***), rediscovered a type of archaism, simplifying either the model or the composition.*

ART NOUVEAU

In the last third of the nineteenth century, Art Nouveau appeared as the first movement which sought to elaborate a radically new style in the field of architecture and in the decorative arts, where eclectism had reigned up to then. Stylistically Art Nouveau is not easy to define for it assumed different forms according to the personality of those who adhered to the movement. Some of these were: Victor Horta in Brussels, Hector Guimard in Paris, Emile Gallé and Louis Majorelle in Nancy, Otto Wagner and Joseph Hoffman in Vienna, Mackintosh in Glasgow. On the whole, Art Nouveau pursued an organic ideal aimed at reuniting form and decoration.

TOWARDS THE TWENTIETH CENTURY

A self-taught artist, Le Douanier Rousseau holds a place all his own in the great movements of the end of the century. His exotic and fantastic subjects, often with symbolist overtones, are treated in a purposely «naif» and very modern style, which heralded the «revolutionary» movements of the twentieth century (see **The Snake Charmer***).*
While the members of the «Nabis» (Bonnard, Vuillard, Maurice Denis, Valloton, Roussel), a society which had been formed in the early 1890s, never abandoned the decorative nature of painting, at the turn of the century they forsook their simplified areas of uniform colour to explore the spacial virtualities of colour. This study of the evocative power of pure colour led to Fauvism which appeared at the Autumn Salon of 1905 (Matisse, Marquet, Derain). In a parallel manner, the three-dimensional combinations of geometric forms of Seurat and Cèzanne (to whom large retrospective exhibitions were granted in the Salons of 1905 and 1907) prefigured those of the Cubist painters (Picasso, Braque).

Henri Rousseau
(Le Douanier) (1844-1910)

The Snake Charmer

Henri Rousseau led the tranquil, monotonous and unobtrusive life of a clerk in the customs office of Paris. The strange imaginary world filled with tropical forests inhabited by exotic animals and figures and the style all his own almost seem to have been created as a reaction against the drab anonymity of his existence.
Rousseau never set foot outside France and his precise description of this primitive Eden and its exotic plants was the result of frequent visits to the Jardin des Plantes and an assiduous study of magazines such as «Magazin pittoresque» and «Journal des Voyages».

Arthur and the Knights of the Round Table. Direct acquaintance and admiration for the works of Botticelli, Mantegna and Michelangelo led him to develop a distinct style of his own: his languid knights are anything but virile and warlike, charming effeminate young men rather than fighting soldiers, and his pale ambiguous maidens lack all sensuality, their sinuous bodies imbued with a nostalgic beauty.

Seen in this light, the traditional subject matter of the Wheel of Fortune has been transformed by Burne-Jones into something more monumental, with brooding figures which were to provide a model for the Symbolist painters of French decadentism.

Edward Burne-Jones (1833-1898)

The Wheel of Fortune

English poet and painter, Edward Burne-Jones was one of the leading exponents of the Pre-Raphaelite movement, a disciple and friend of Dante Gabriel Rossetti.

The Pre-Raphaelite Brotherhood promoted an aesthetizing movement, a veritable worship of beauty, based on their admiration for the art and culture of the Middle Ages. Most of the subjects Burne-Jones dealt with were of a mystical and allegorical nature, inspired by the traditional English sagas, the enchanted incorruptable world of King

Odilon Redon (1840-1916)

Closed Eyes

The artist, well-known for his charcoal drawings and lithographs which reflect an anguished personality with a tendency to create an imaginary obsessed world, created serenely beautiful figures when he introduced colour in his works.

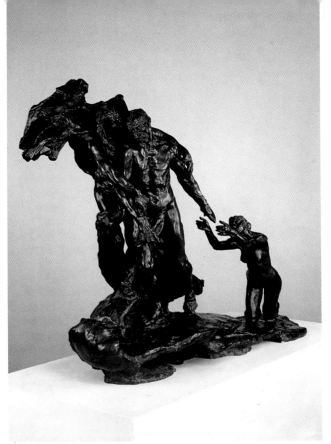

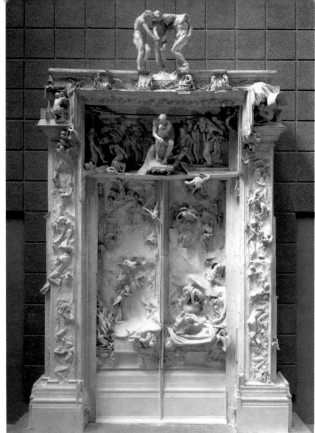

Camille Claudel (1864-1943)

Mature Age

A tormented artist who spent the last thirty years of his life in a private clinic, Camille Claudel was a friend of Rodin's and was influenced by him. Some of his works, however, like this one dated 1899, reveal a deep-seated sense of suffering.

Auguste Rodin (1840-1917)

The Gate of Hell

Commissioned for the Musee des Arts Décoratifs, the Gate of Hell began to be modelled in plaster in 1880. It harks back to the themes developed in the Divine Comedy but Rodin, who loved to play with floating masses and empty spaces never finished this gate where the sculptures were, in a sense, prisoners of the architectural frame.

Antoine Bourdelle (1861-1929)

Penelope

Bourdelle worked with Rodin but succeeded in maintaining his own autonomous personality, inspired by the lesson of Archaic Greek art. This splendid Penelope wearing a gown whose folds call to mind some of the loveliest kore figures is a fine example.

Hector Guimard (1867-1942)

Piece of Furniture

Guimard was one of the greatest French architects – more pecisely in his own words – he was an «architect of art». He designed only a limited number of pieces of furniture. This example, created for the billiard room in Roya aux Gevrils, in the Loiret, in 1897-98, is of particular note for its sinuous lines and elegant curves.

It is as if the stem of a plant were to rise from the earth and then freely develop in space. Guimard himself wrote: «When I design or sculpture a piece of furniture I reflect on the spectacle that Nature offers us».

Aristide Maillol (1861-1944)

Mediterranean

Maillol began as a painter, an activity he continued until 1904. He tried his hand at all the arts including tapestry and ceramics under the influence of Gauguin, and sculpture.

His figure of the Mediterranean, made for the Town Hall of Perpignan, is one of the major pieces of sculpture by this eminently classical sculptor of the early 1900s. Thanks to a donation by his favorite model, various statues in bronze, including this one, were set up in the Park of the Tuileries in 1964.

Emile Gallé (1846-1904)

Dragonfly Cabinet

The idea of trying his hand at cabinet-making seems to have occurred to Gallé, an outstanding artist in ceramics and glass, after a visit to a merchant in exotic wood.

His furniture is inspired by nature, the pieces are logical in their structure and well suited to their location, such as this cabinet, known as the «dragonfly cabinet» which was commissioned by the magistrate Henry Hirsch. Gallé generally used soft easily workable woods, together with other materials such as, in this case, mother-of-pearl, semiprecious stones, glass and bronze.

Alexandre Charpentier (1856-1909)

Dining room from the Bénard Villa

This monumental dining room, commissioned around 1900 from Alexandre Charpentier by the banker Adrien Bénard for his villa in Champrosay, is one of the rare ensembles in Art Nouveau style which has come down to us. The twenty-four chairs and the wall lamps which went with the table have disappeared.

The space Charpentier had to work with was already subdivided by a beam set on two metal columns. He thus invented the two large sculptured pillars from which the beautiful but purely ornamental central arch springs. The mahogany panels on the walls are decorated with lovely vines and creepers and two silver cabinets and two consoles were also added.

The result was this masterpiece of harmony and elegance, in which light forms and sinuous animated lines complement each other.

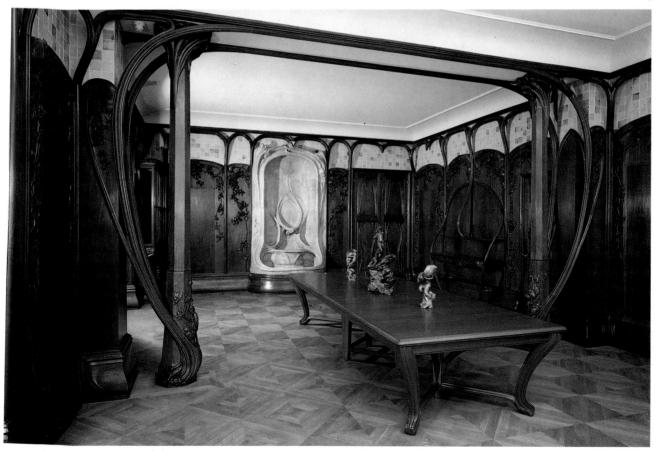

CONTENTS